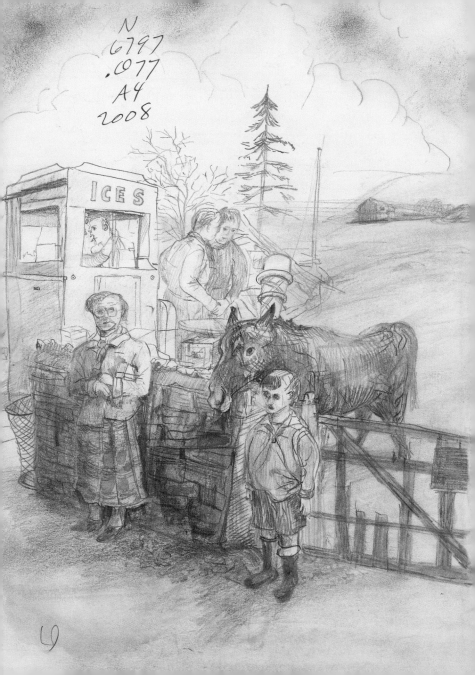

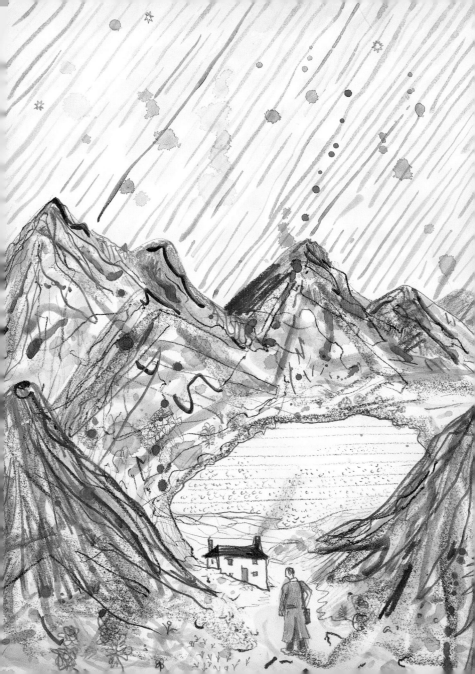

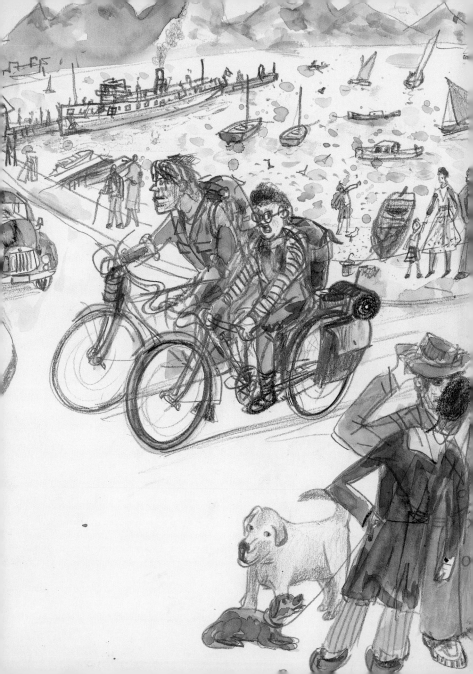

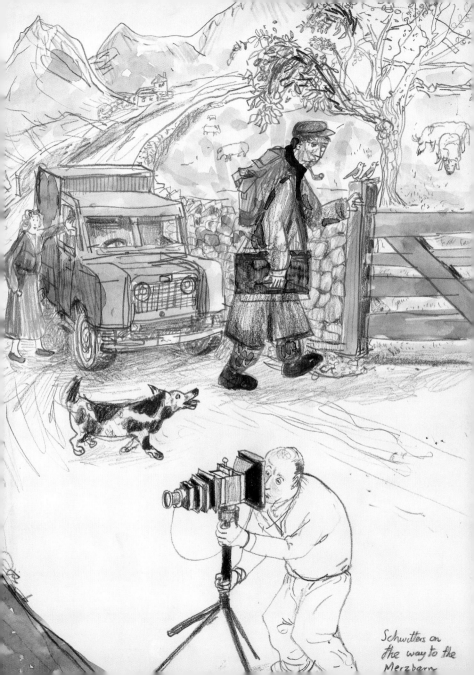

Schwitters on
the way to the
Merzbarn

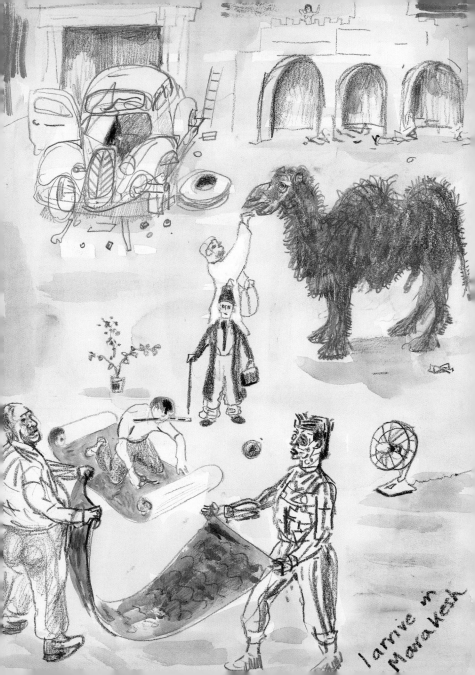

I arrive in Marakeh

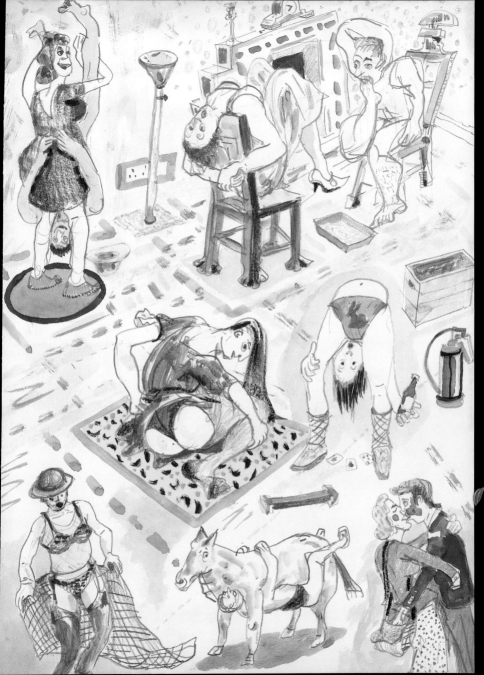

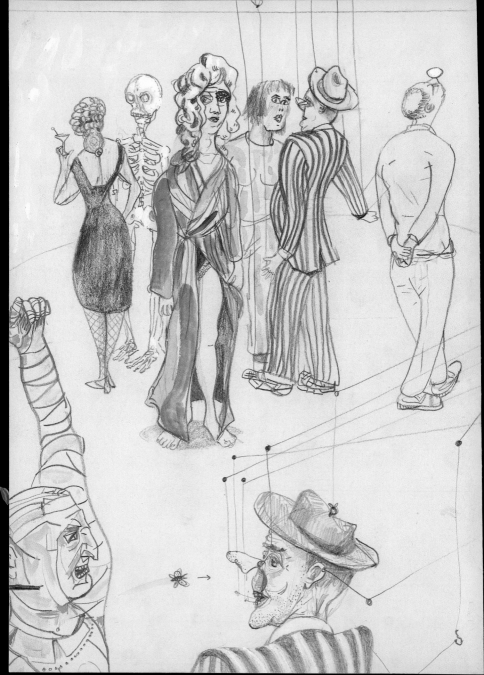

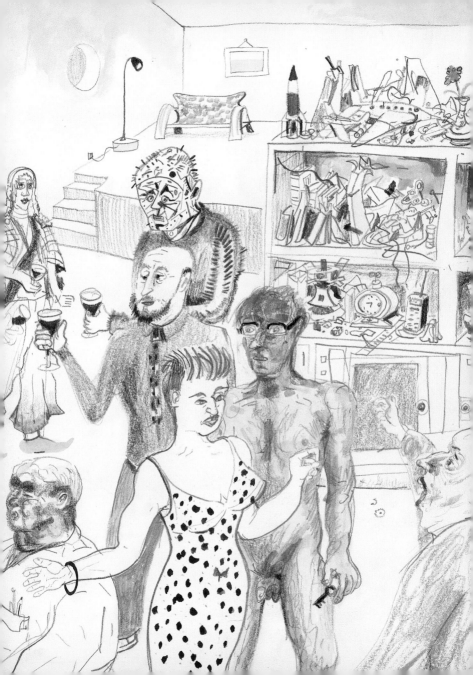

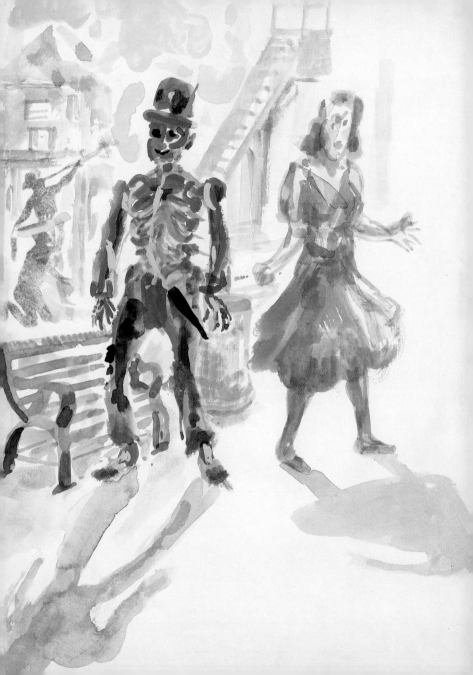

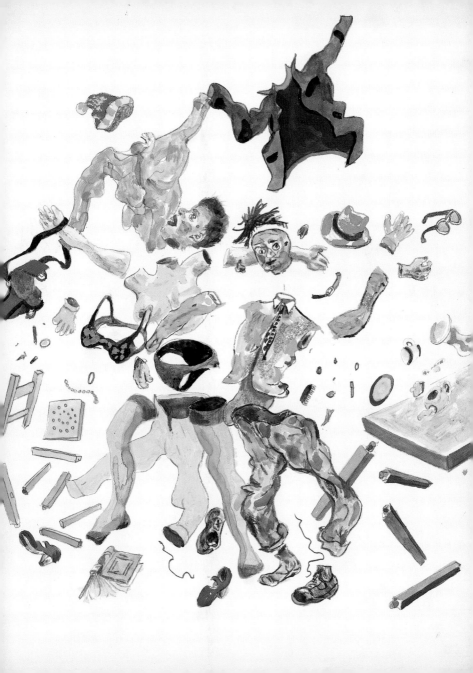

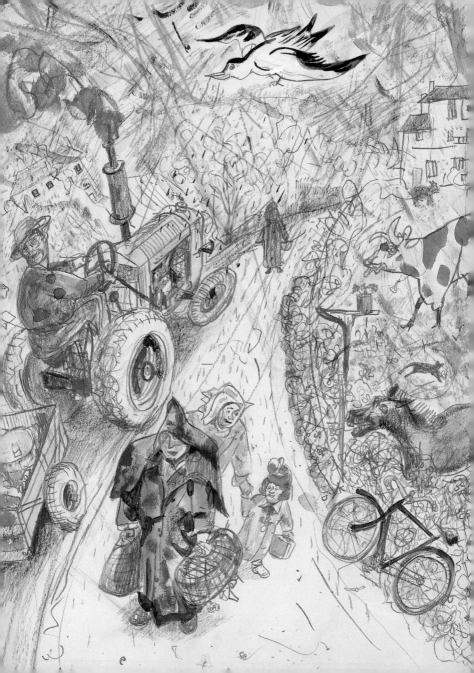

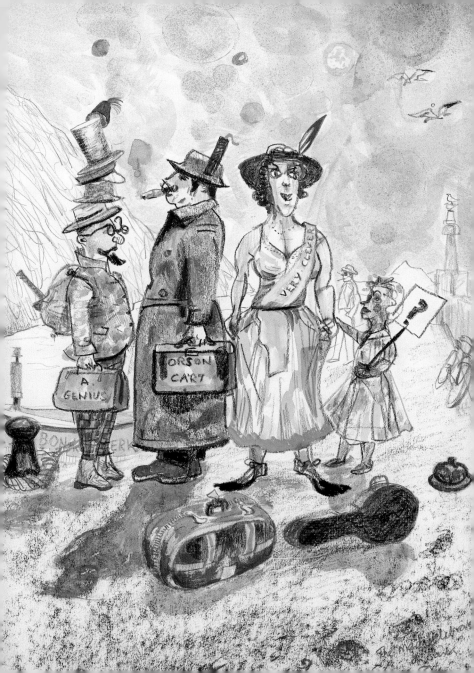

near perfect day

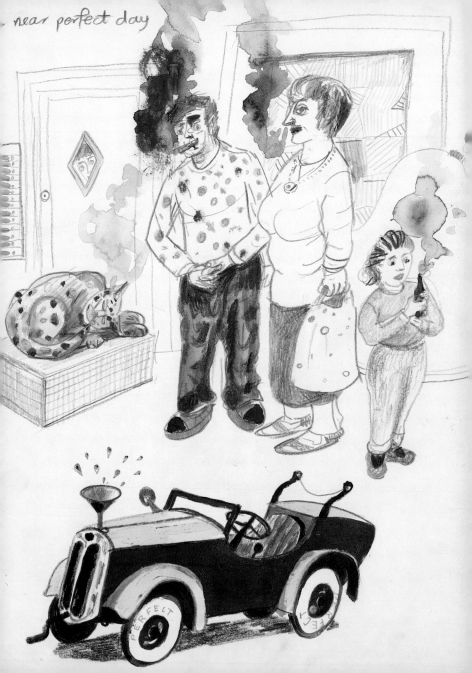

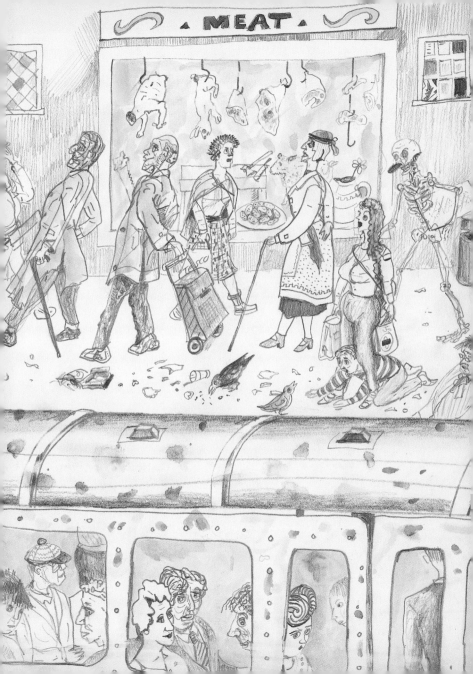

Dog's philosophy; I stink, therefore I am.

cat's philosophy ; I slink. therefore I am.

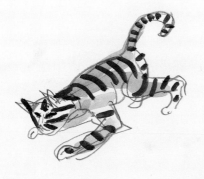

rat; I am not

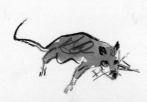

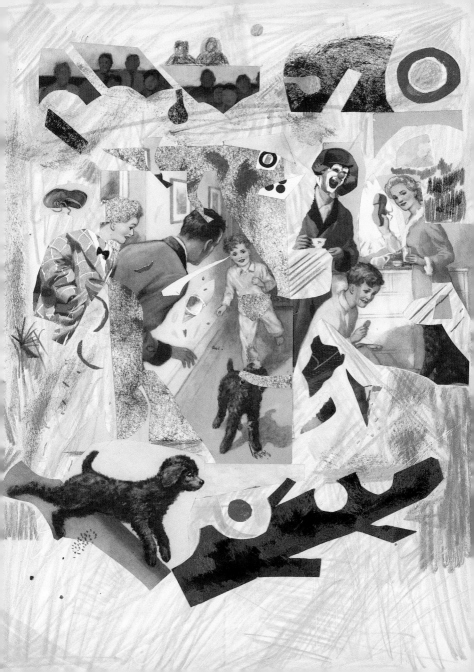

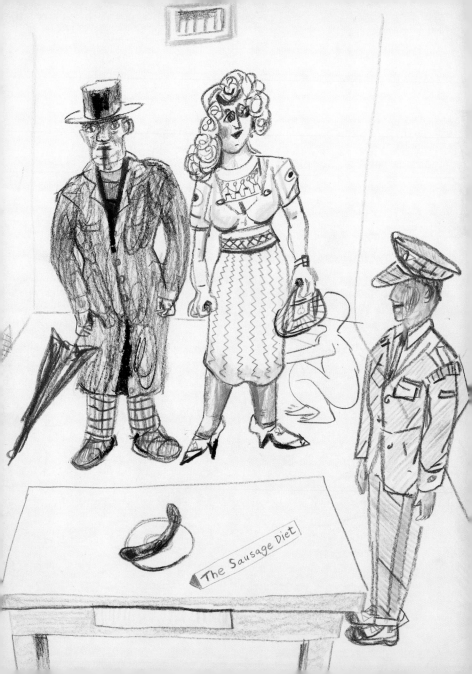

The Sausage Diet

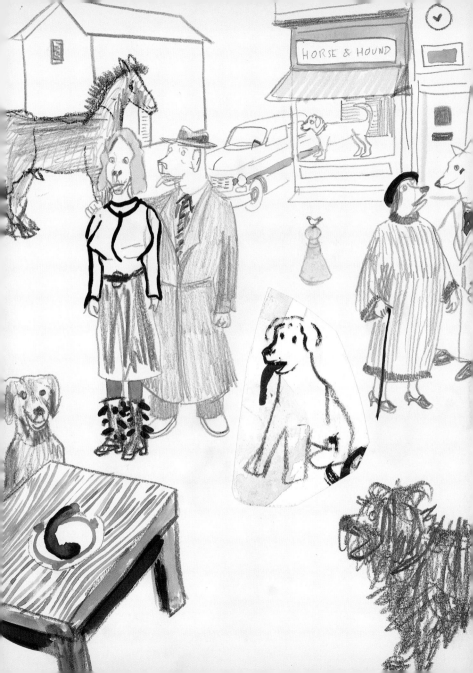

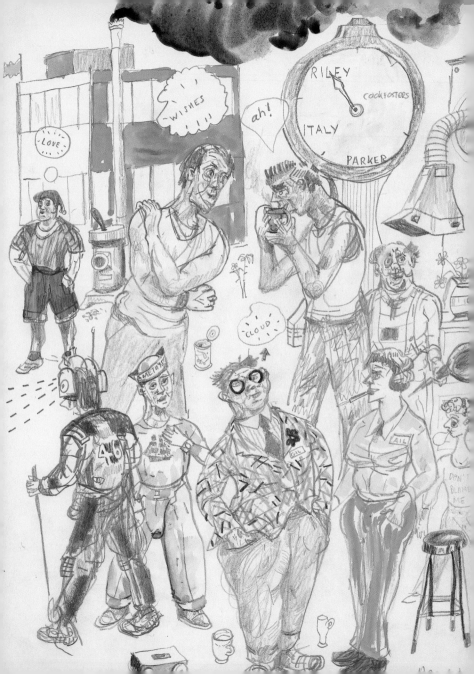

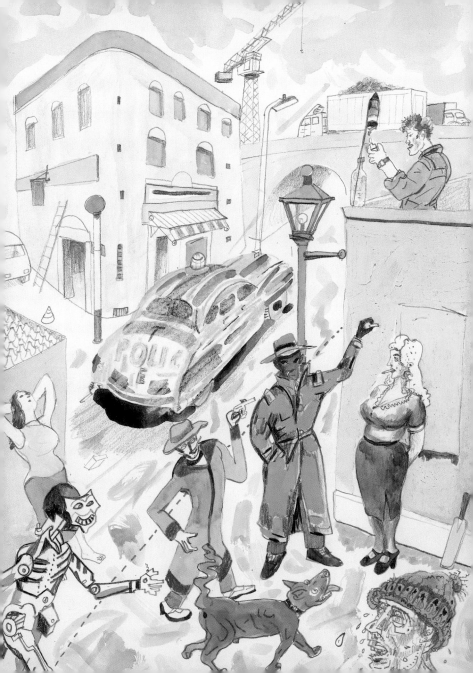

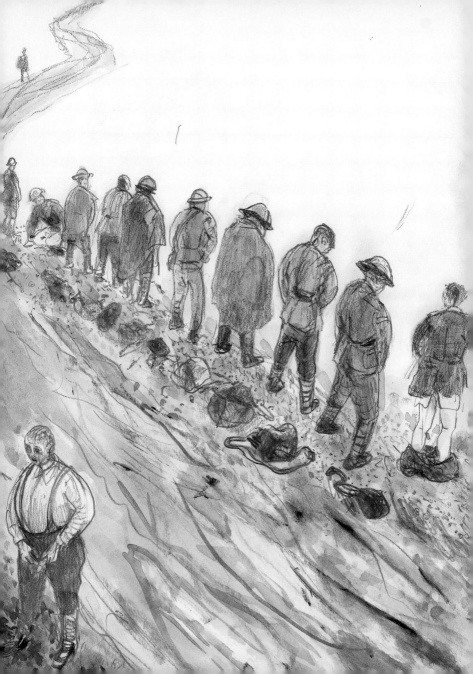

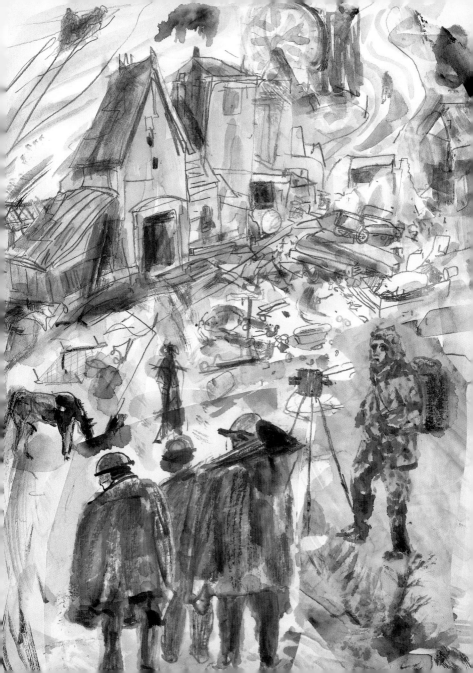

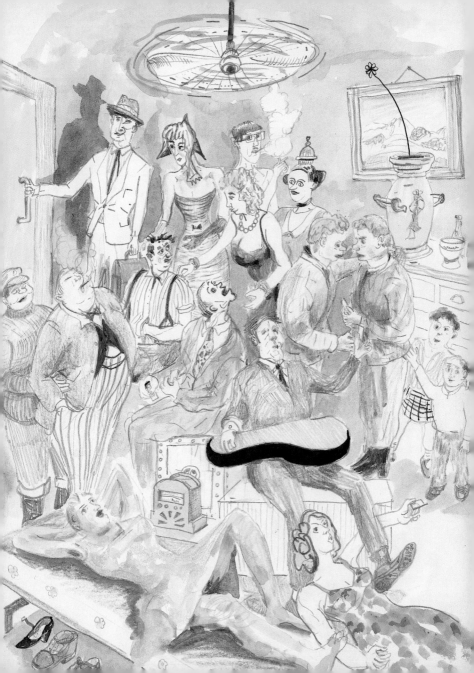

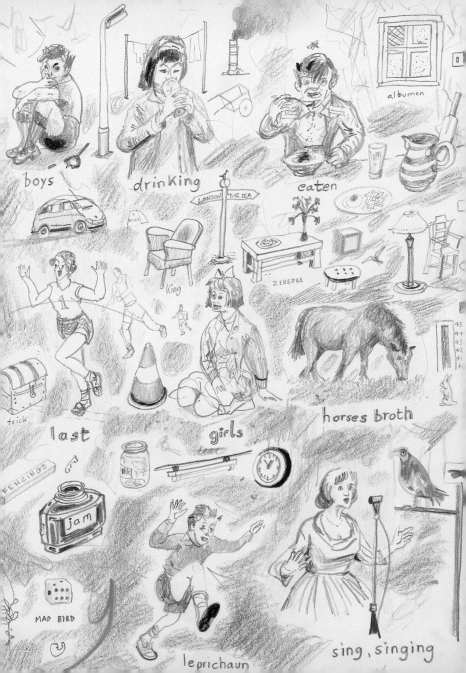

boys

drinking

eaten

albumen

King

LONDON THE SEA

ZEBEDEE

trick

last

girls

horses broth

FENCINGS

MILK

jam

MAD BIRD

leprichaun

sing, singing

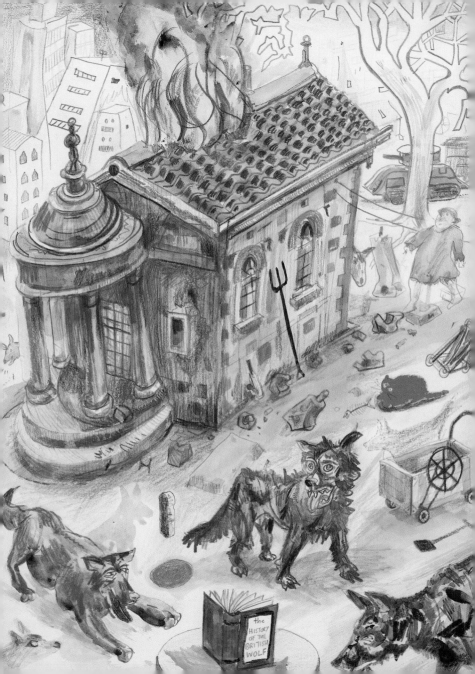

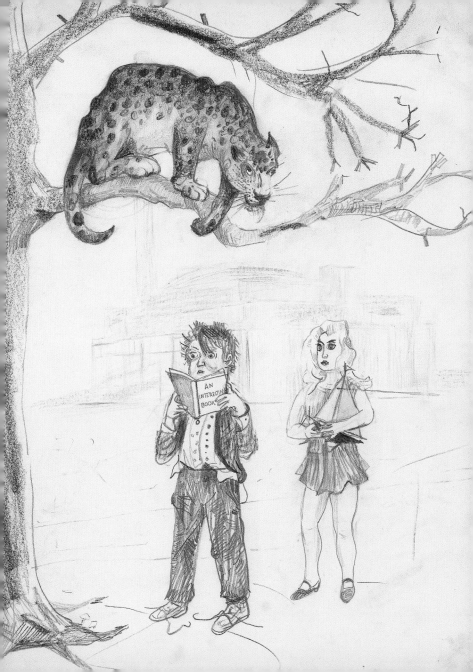

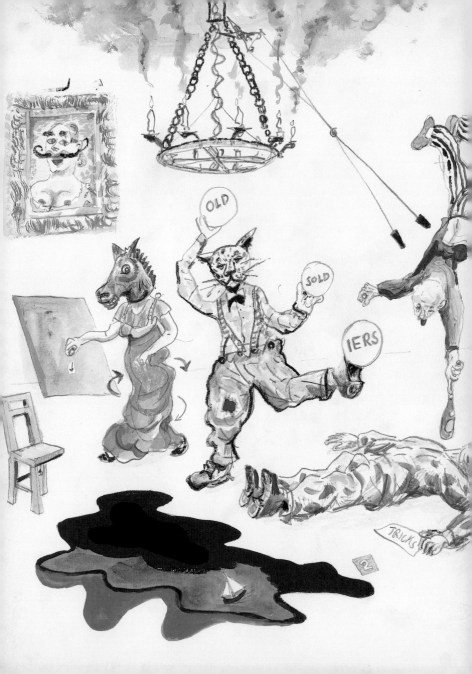

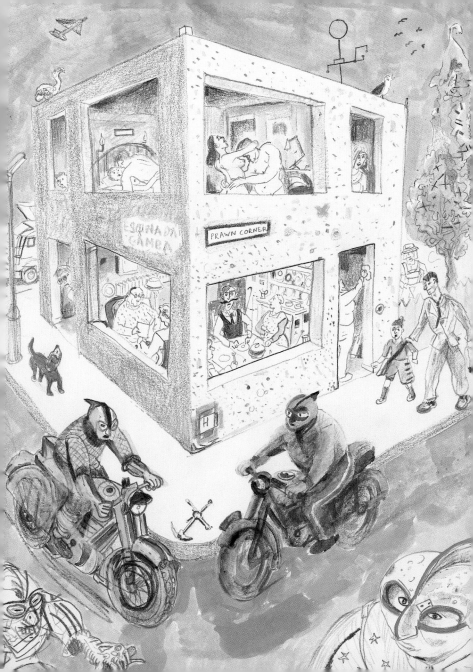

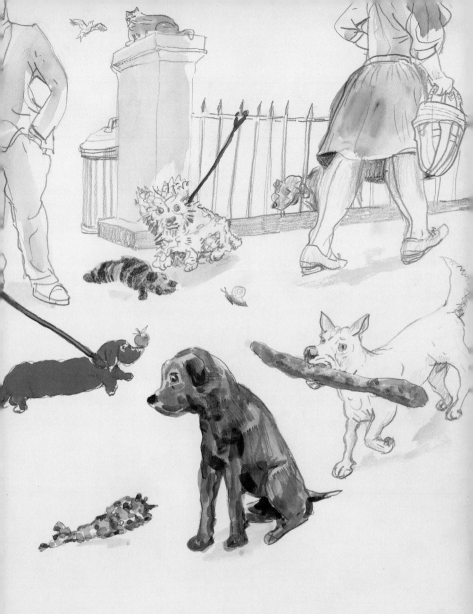

Pets who care.......

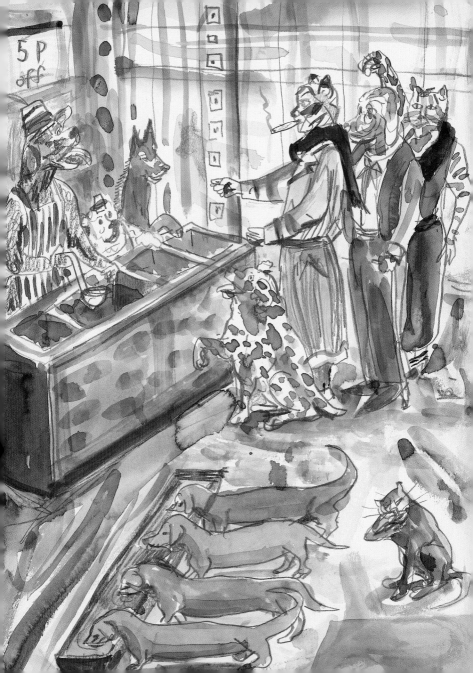

fanfare for the common mug

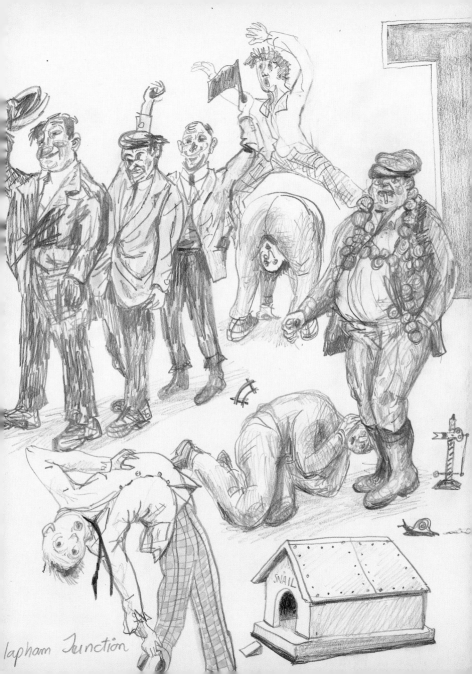

SNAIL

lapham Junction

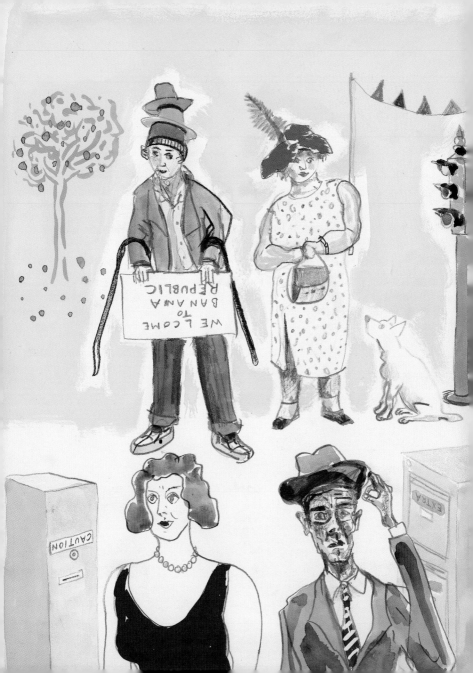

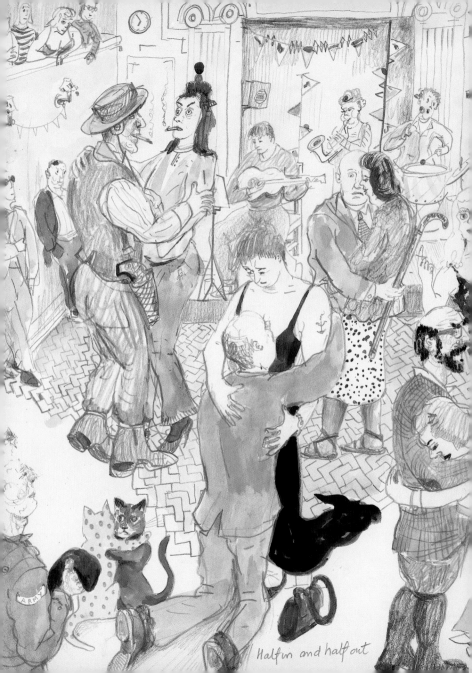

Half in and half out

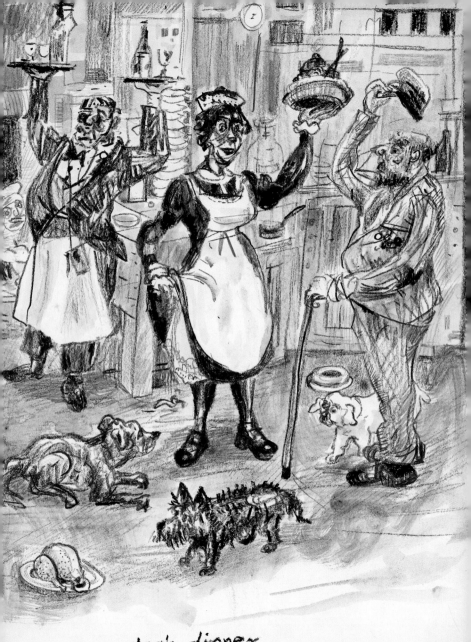

a dog's dinner

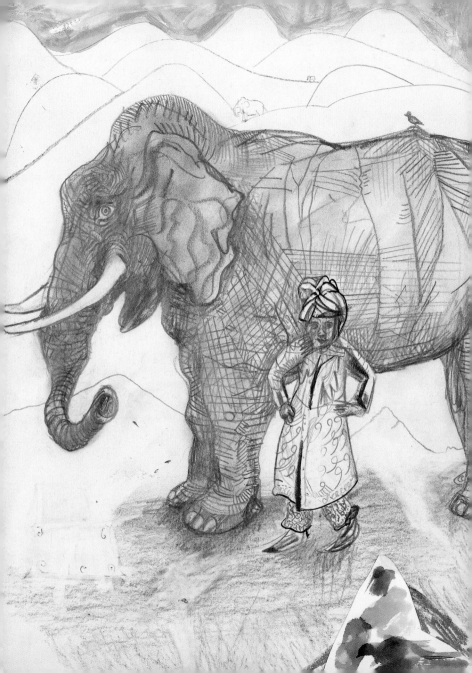

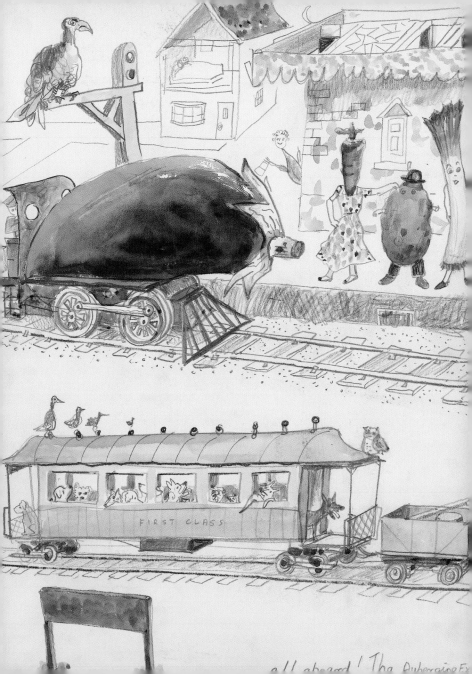

all aboard! The Aubergine Ex

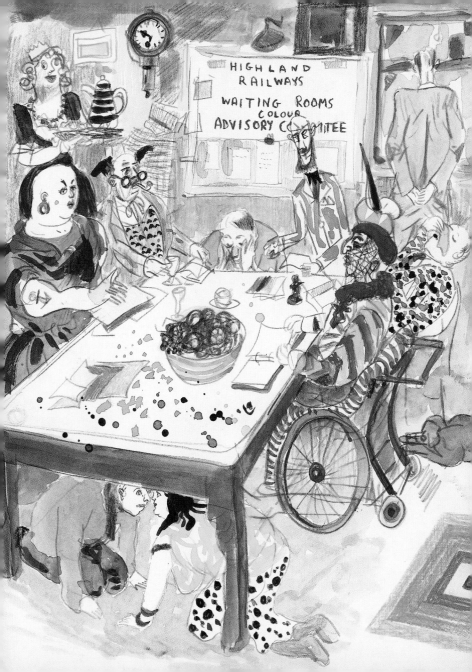

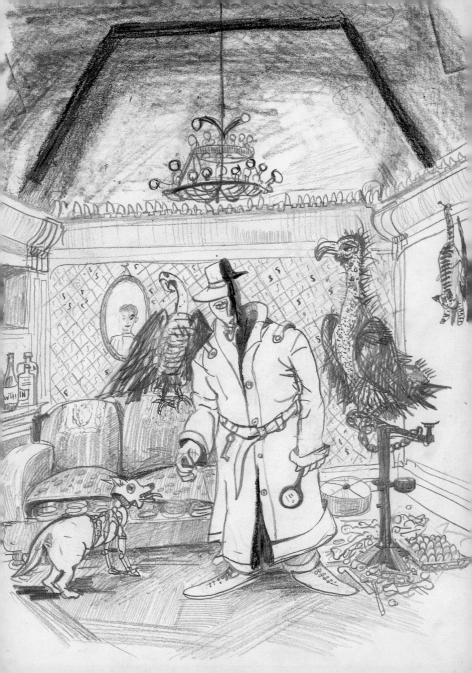

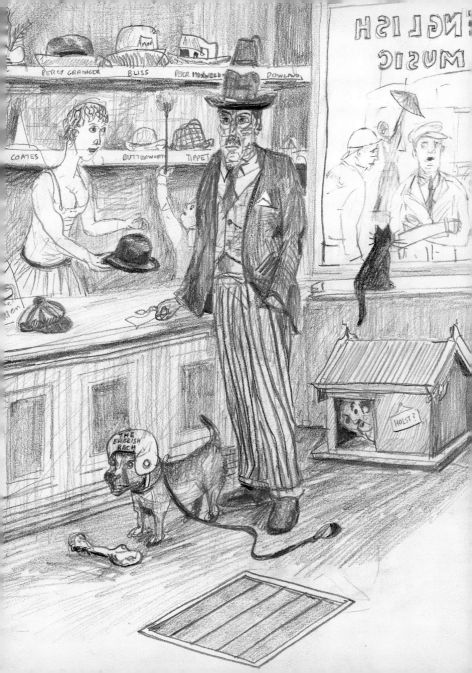

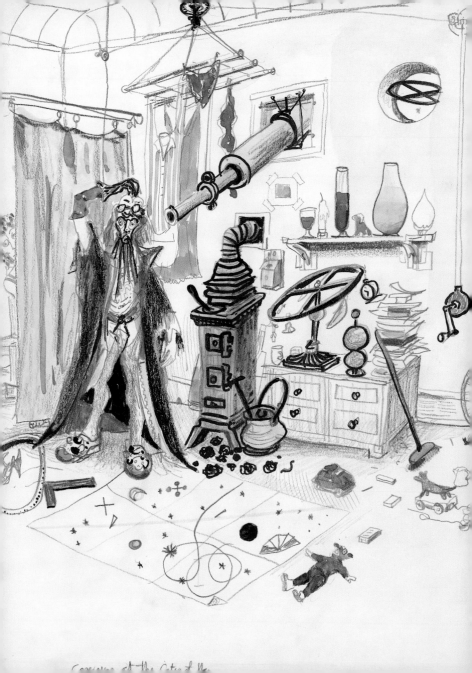

Corsicans at the Gates of ...

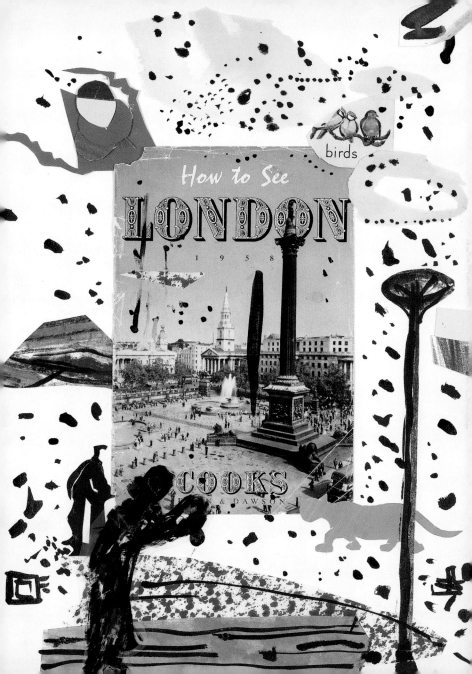

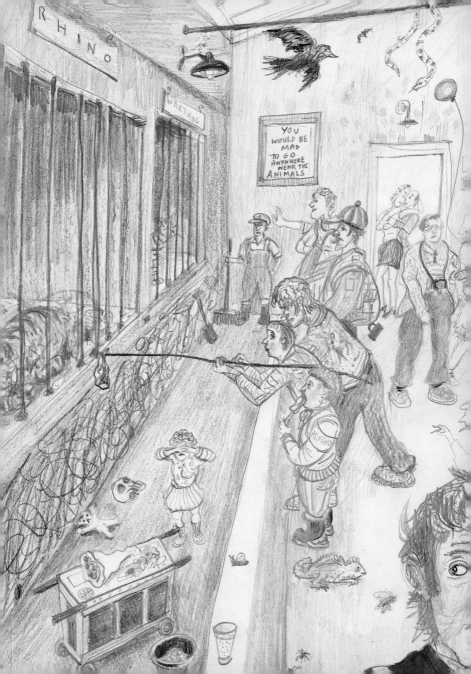

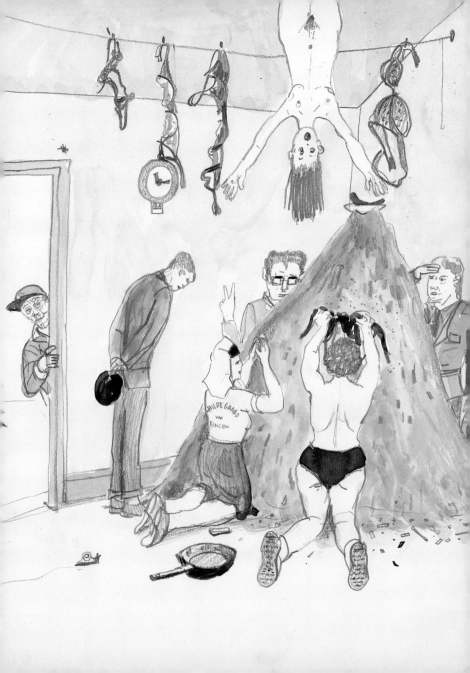

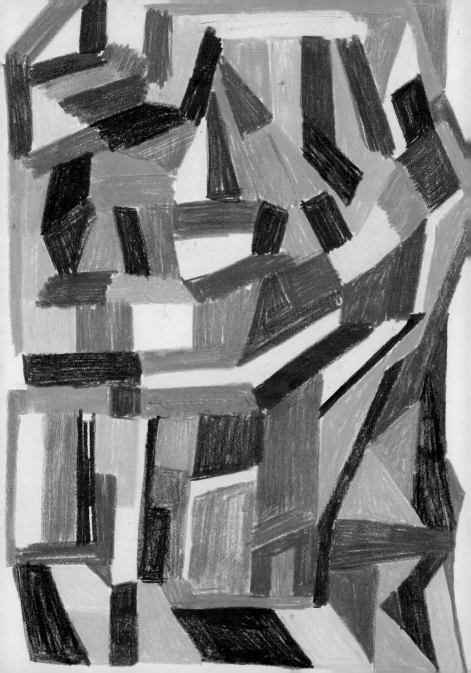

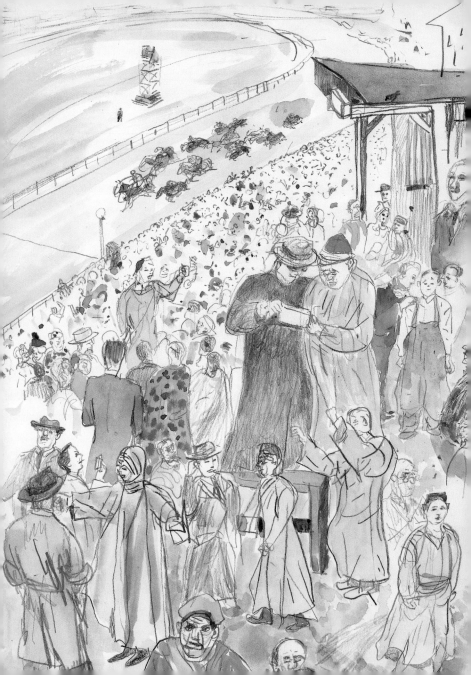

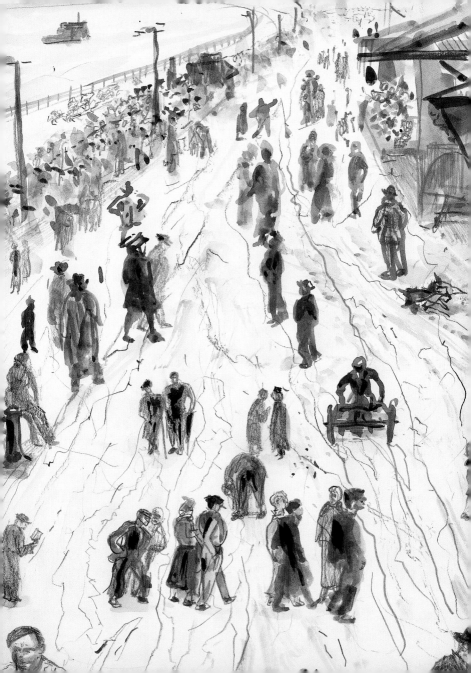

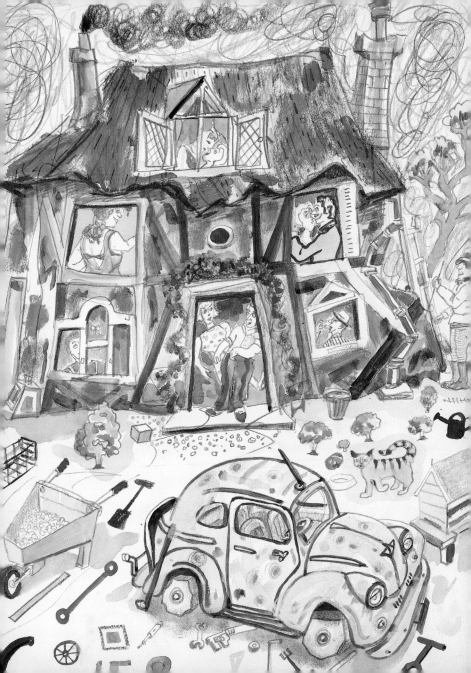

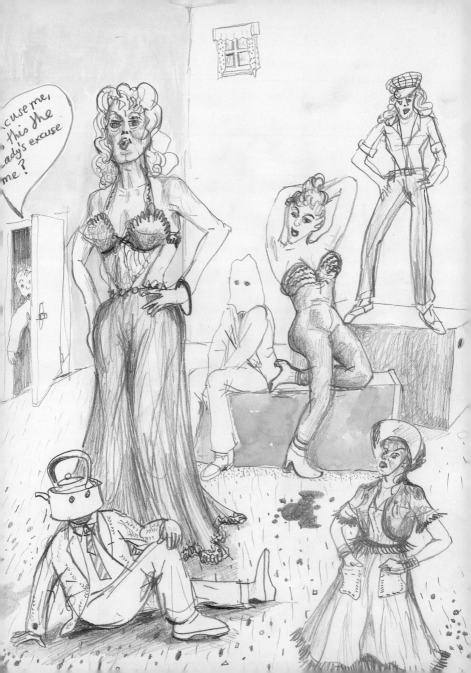

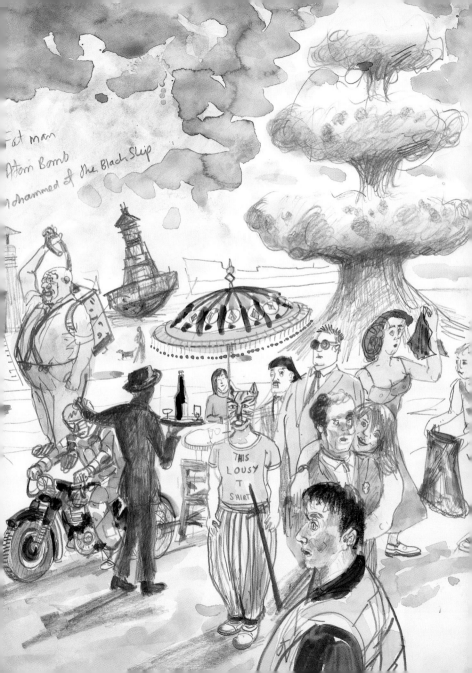

Fat man
Atom Bomb
Mohammed of the Black Slip

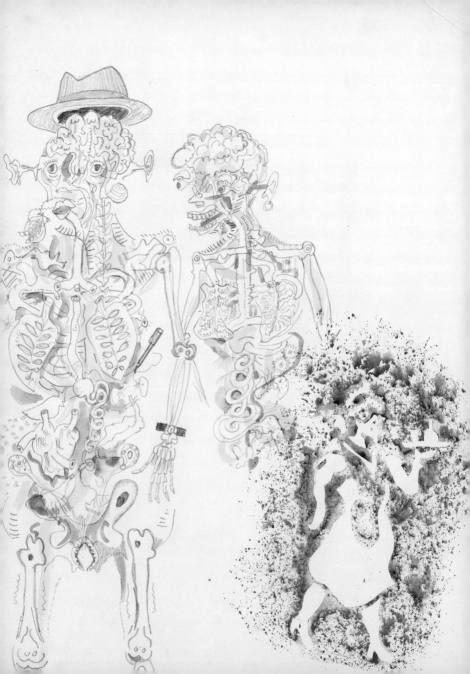

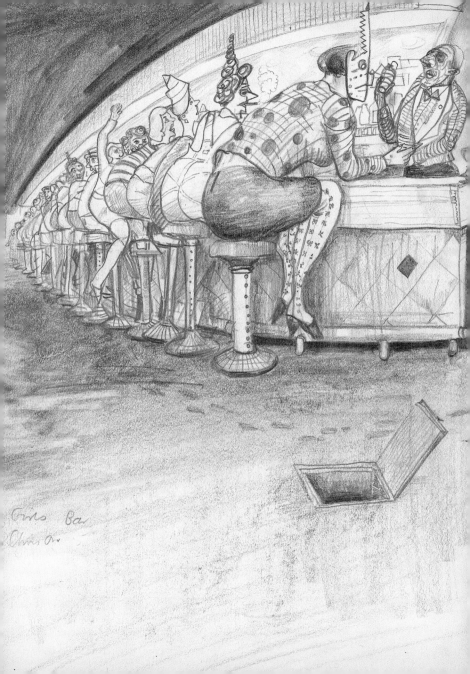

Girls Bar
Christm...

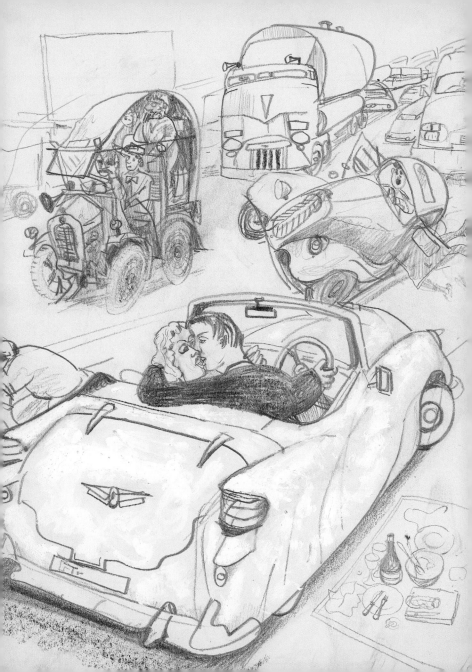

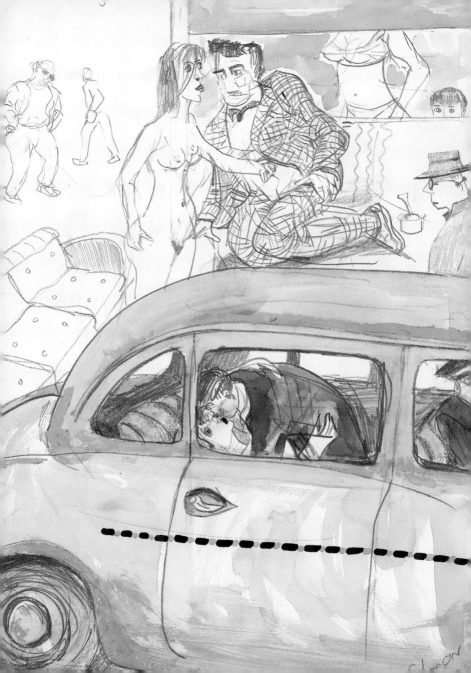

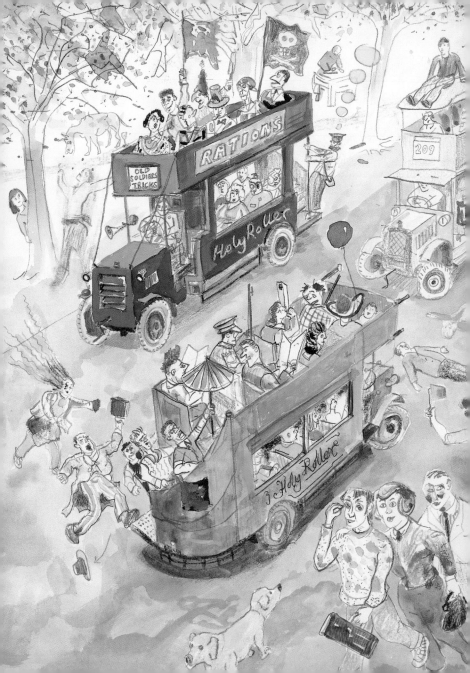

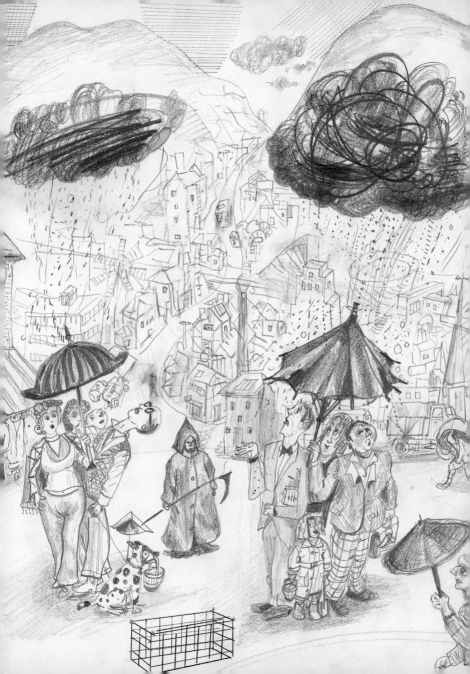

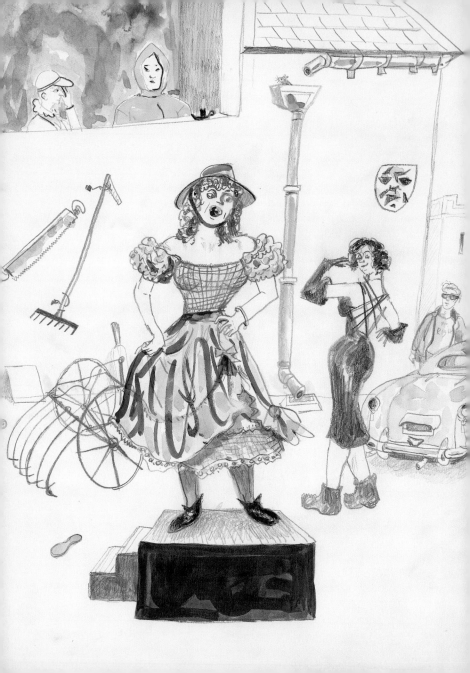

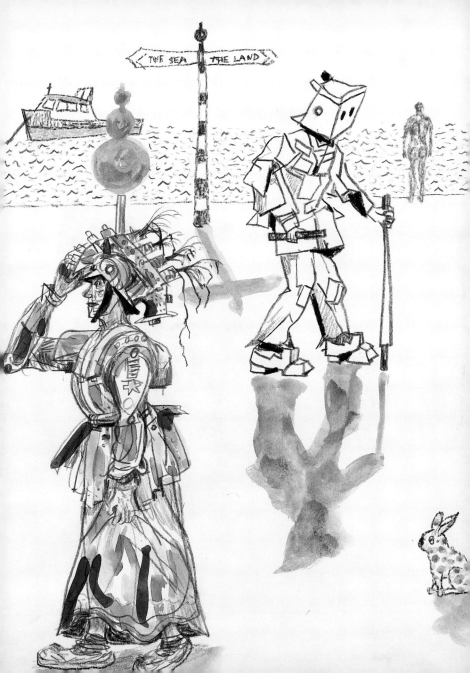

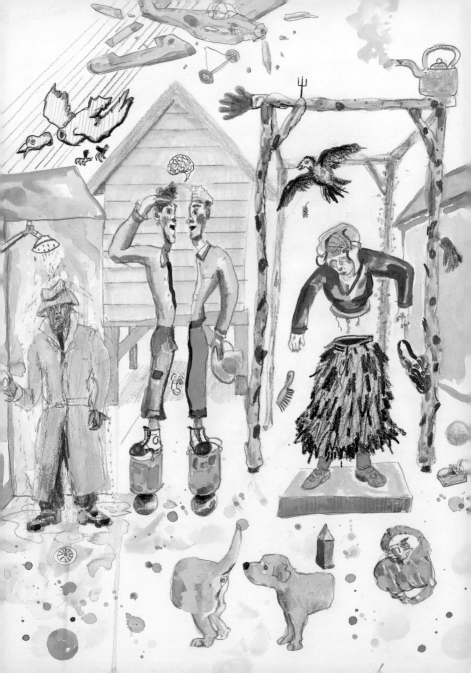

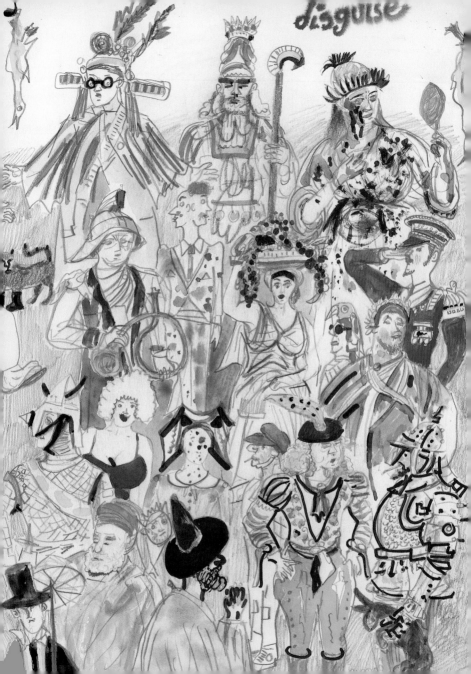

disguise

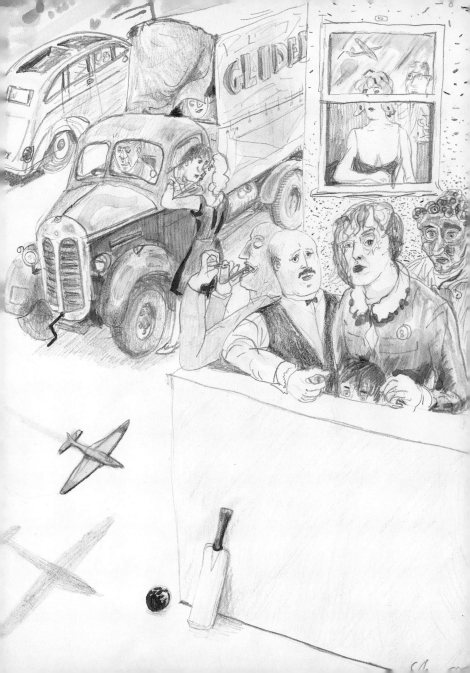

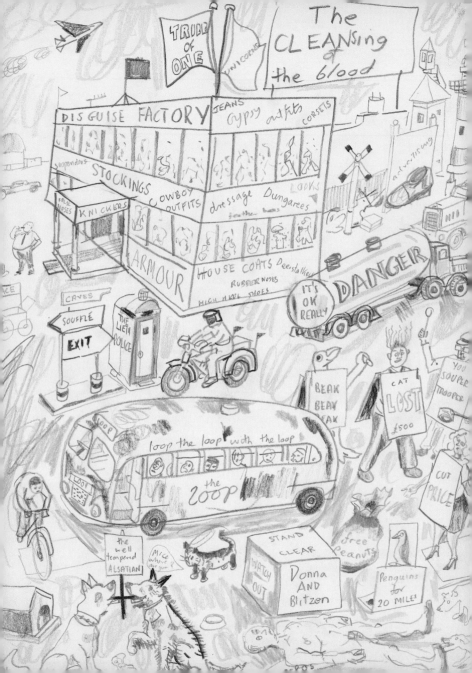

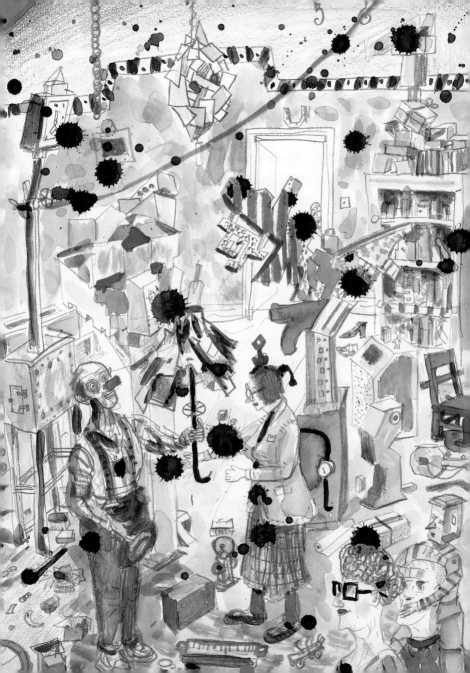

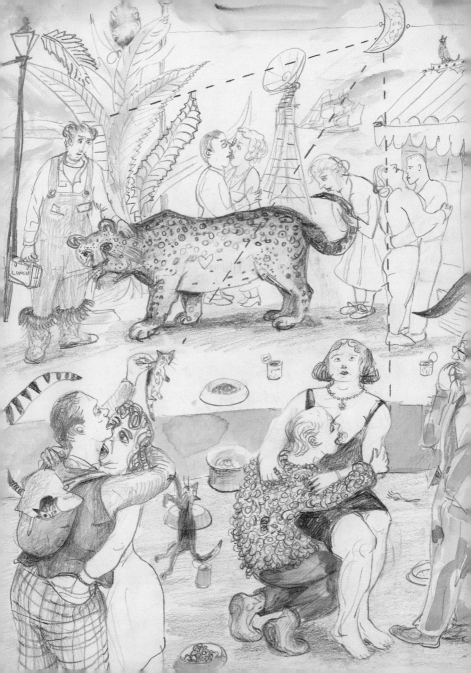

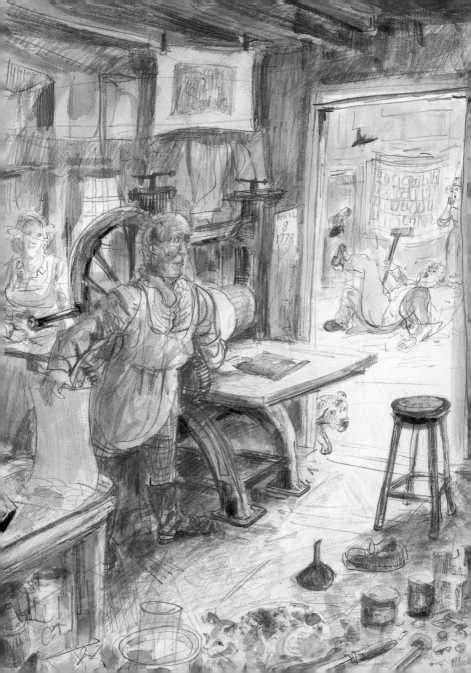

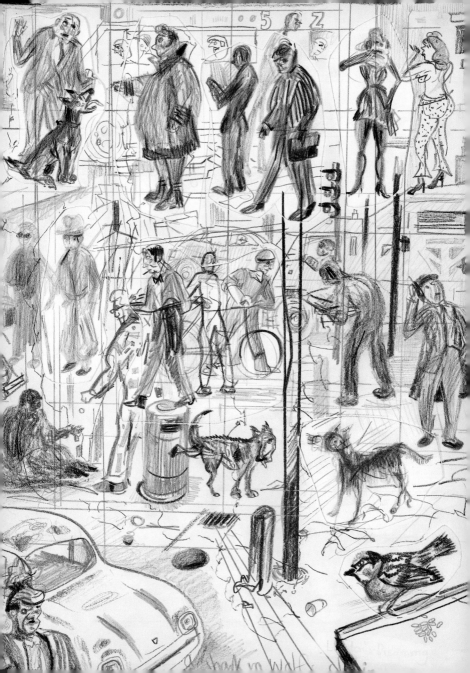

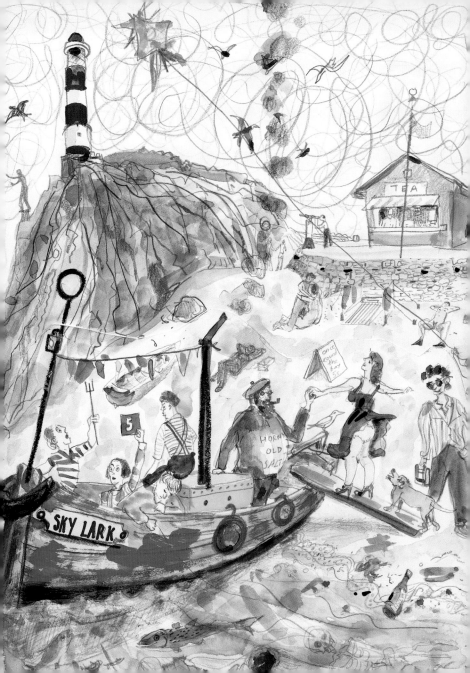

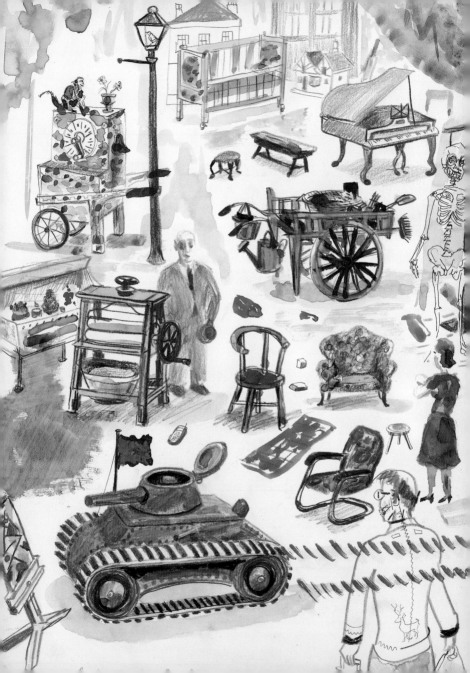

it was quite big

d'yer like my wee bogie

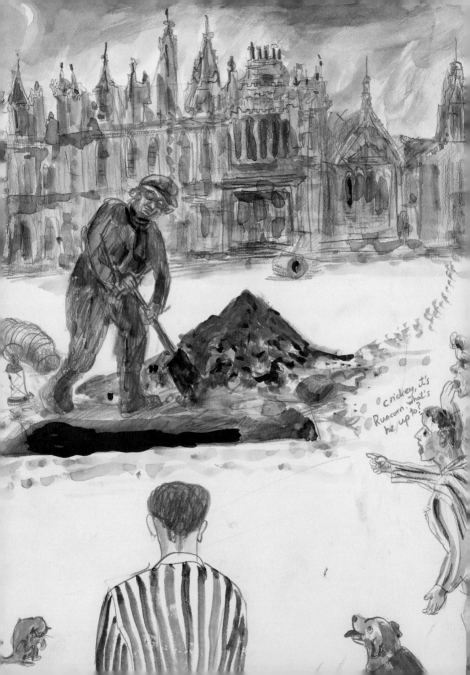

crickey, it's Runcorn, what's he up to?

WANTED

BEER

SPIRITS

WINE

STRONG
CURRENTS

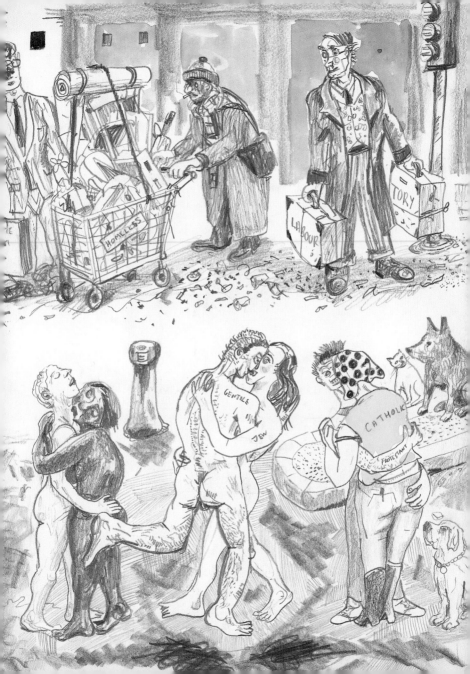

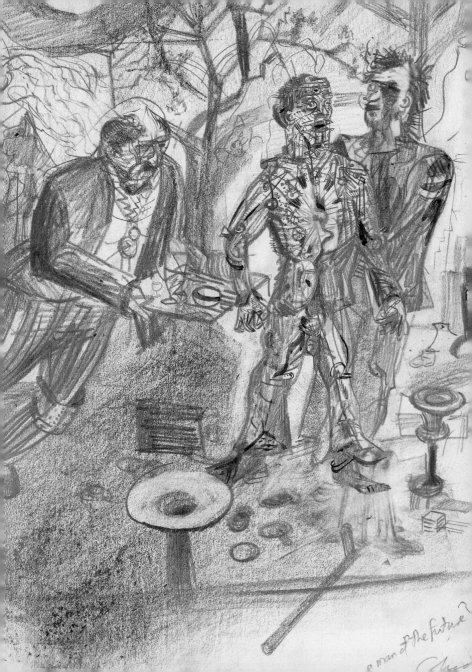

a man of the future?

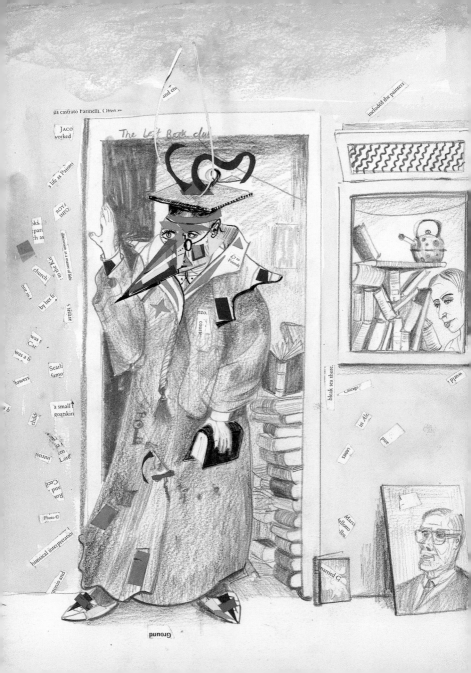

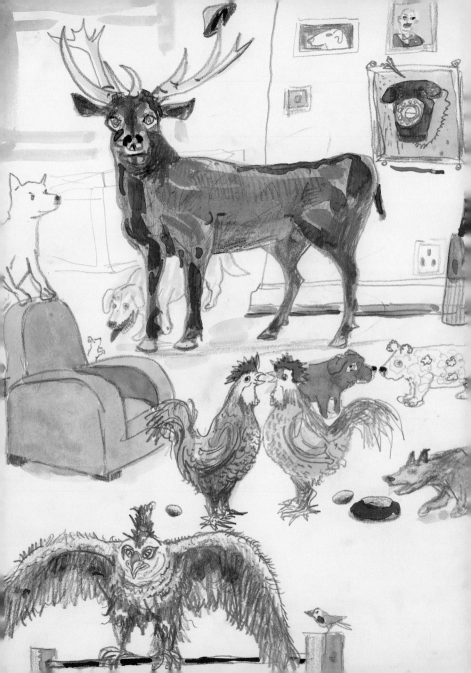

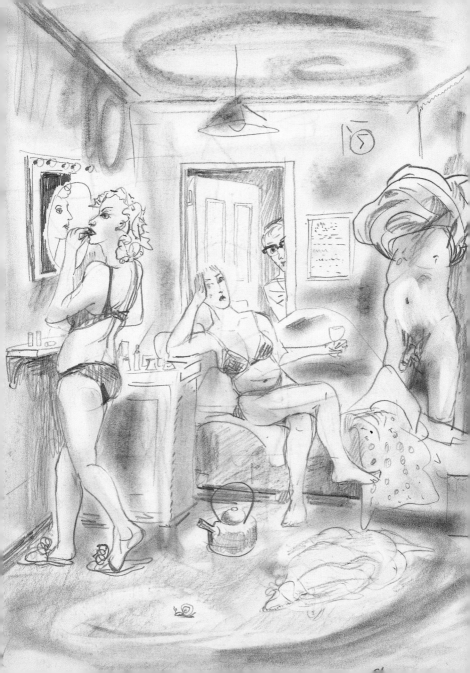

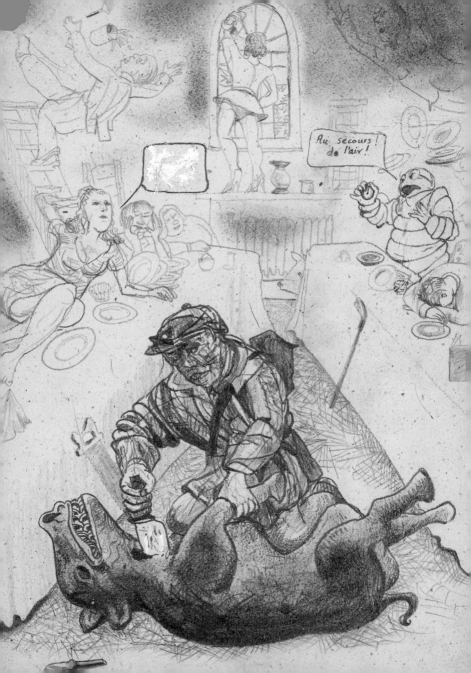

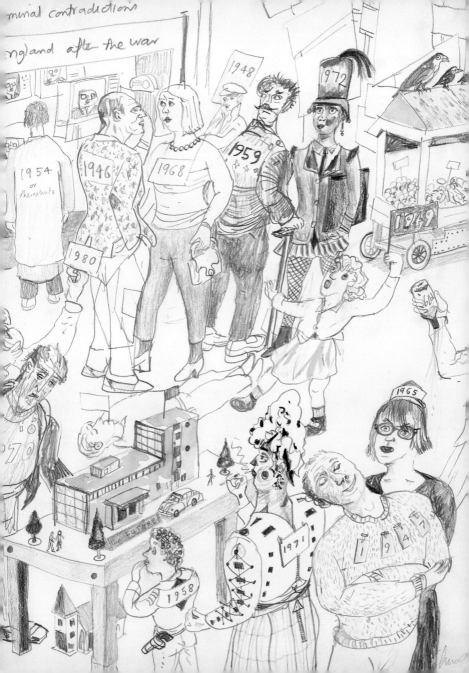

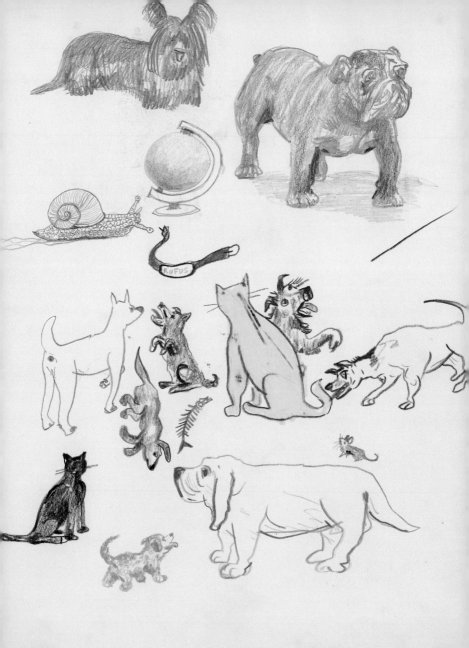

RUFUS

Rufus

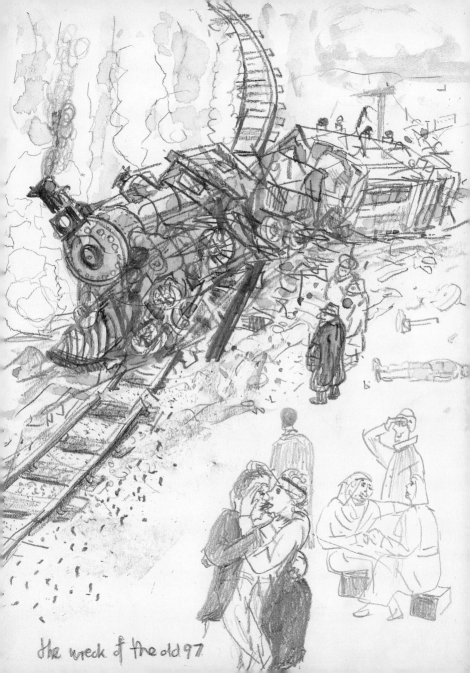

the wreck of the old 97.

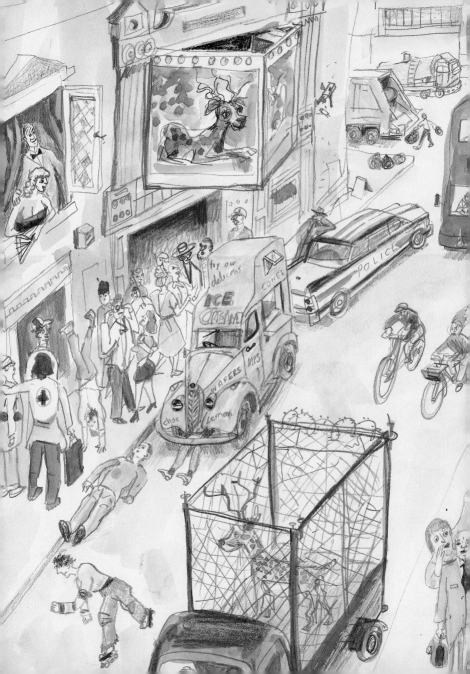

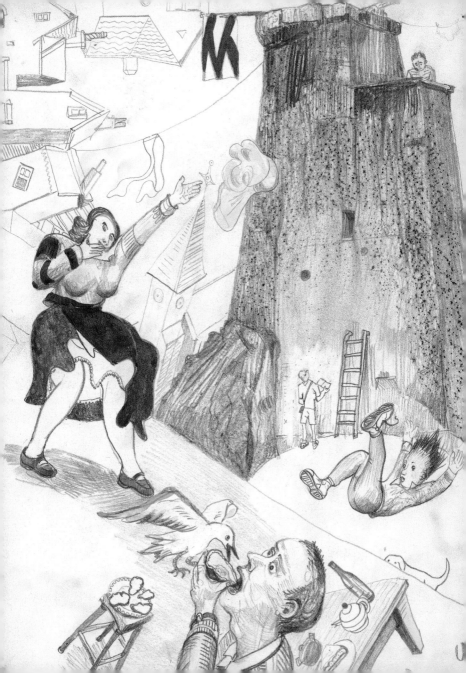

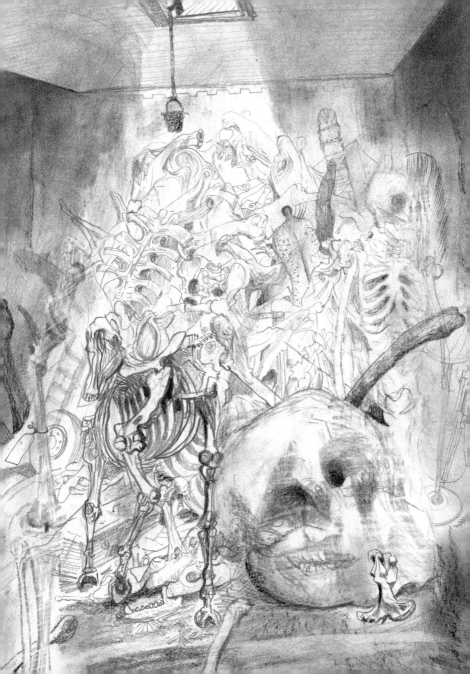

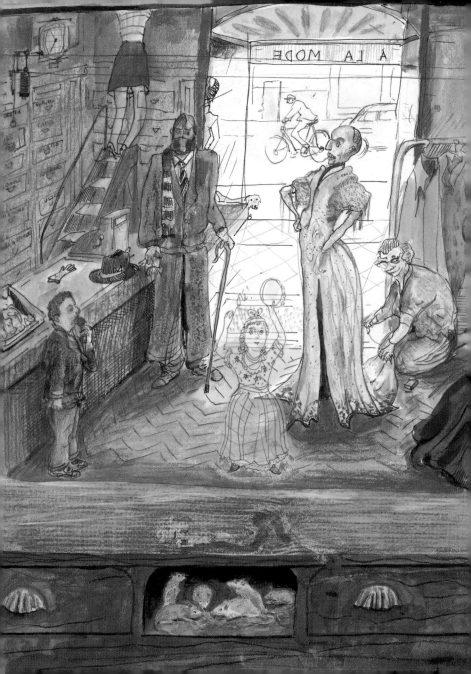

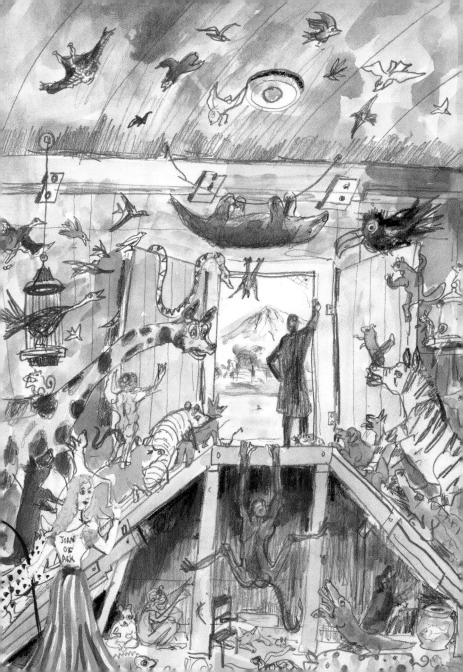

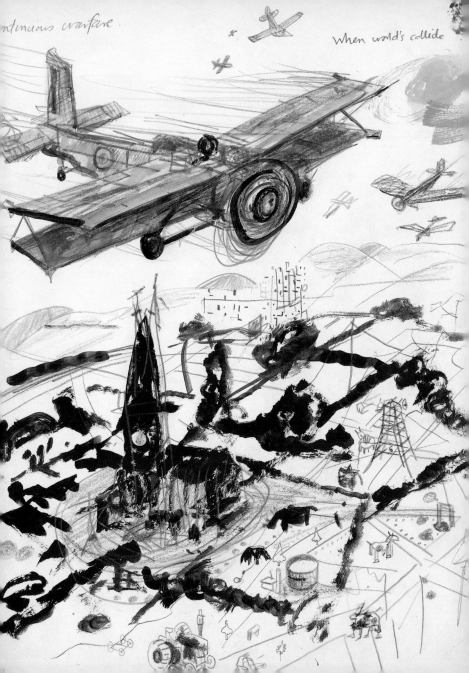

ntinuous warfare.

When world's collide

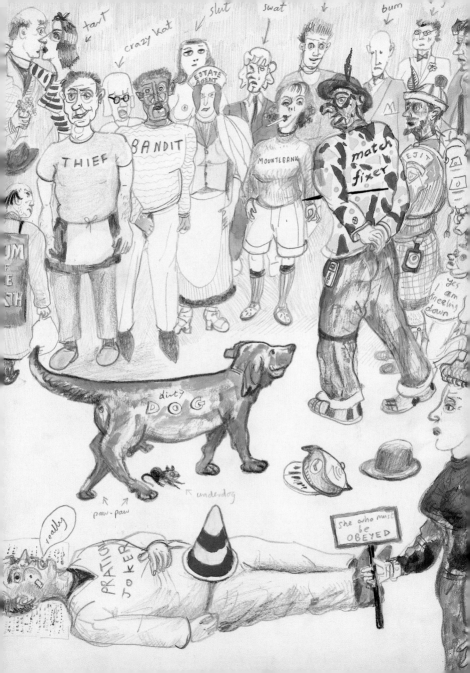

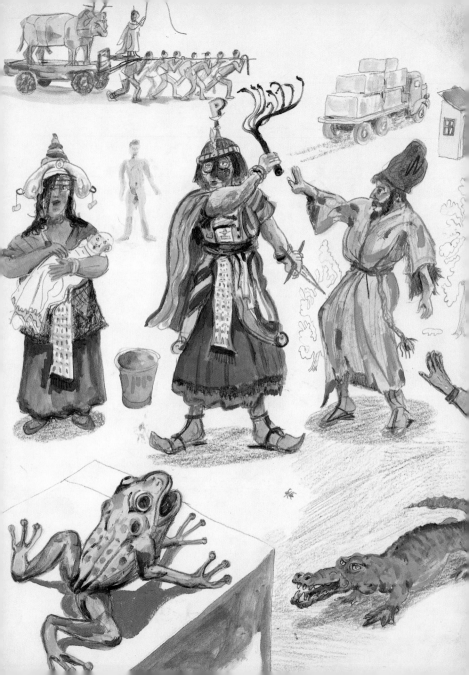

John Cage in a rage

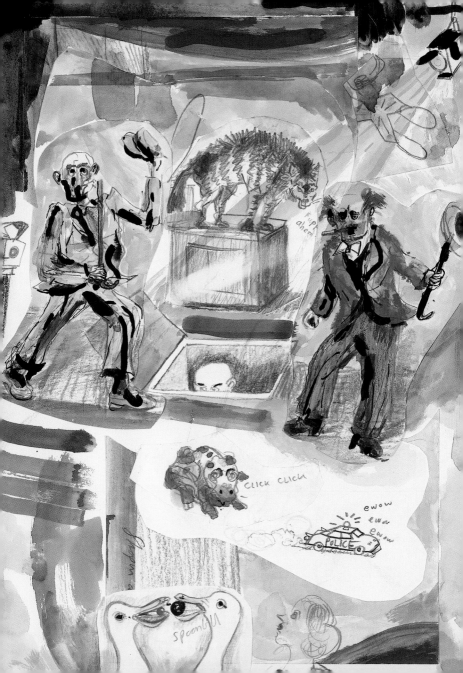

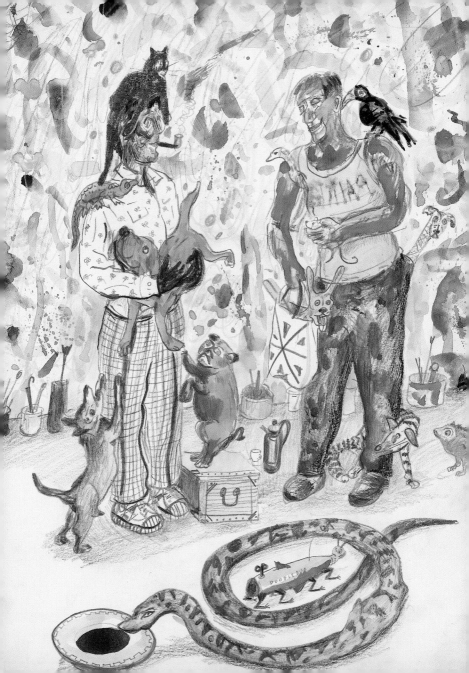

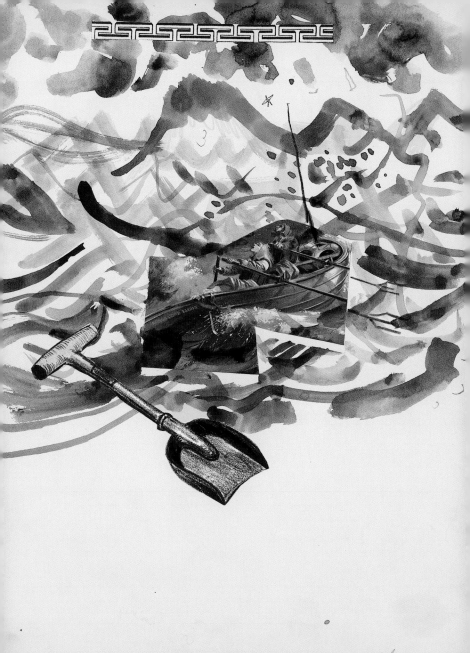

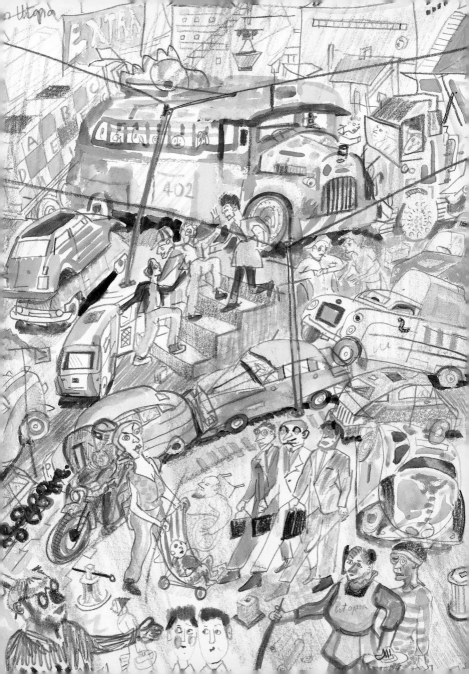

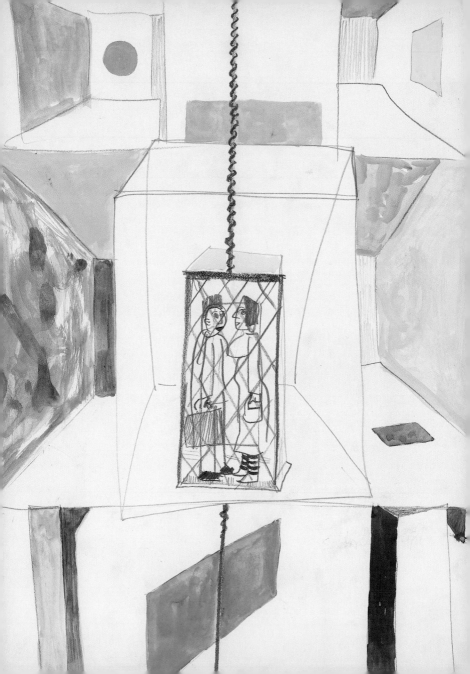

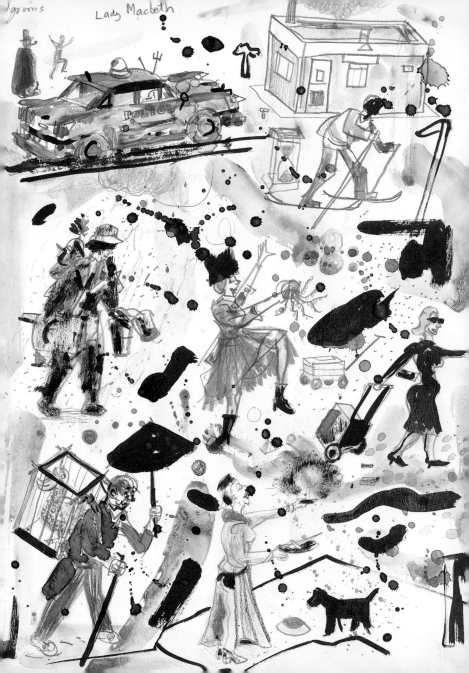

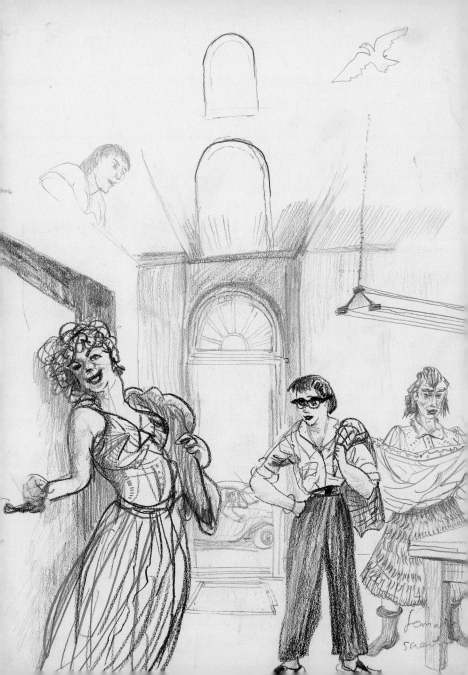

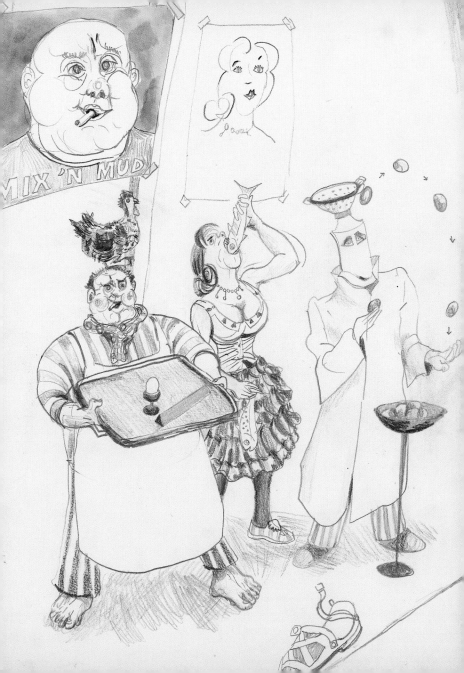

MIX 'N MUD

an alternative Turner Prize

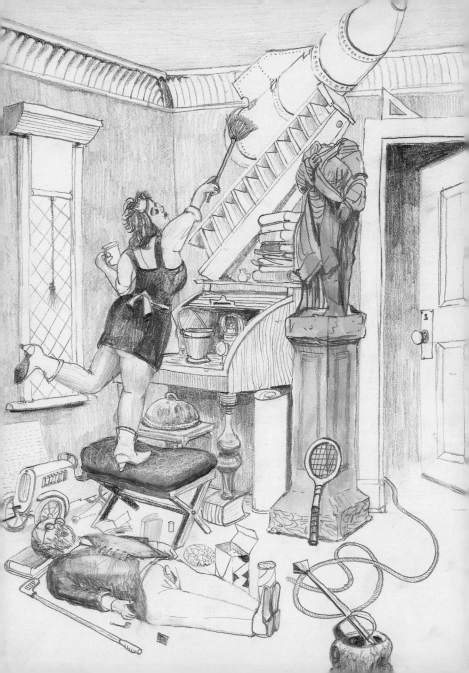

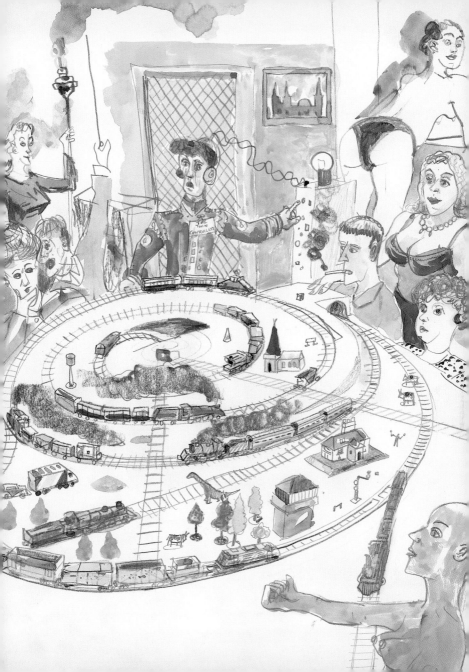

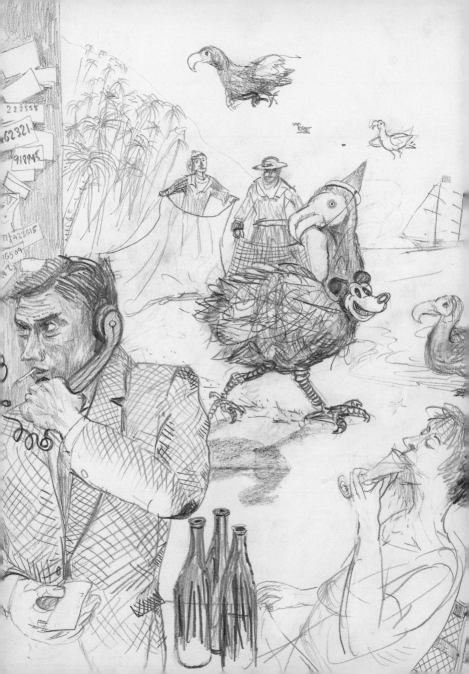

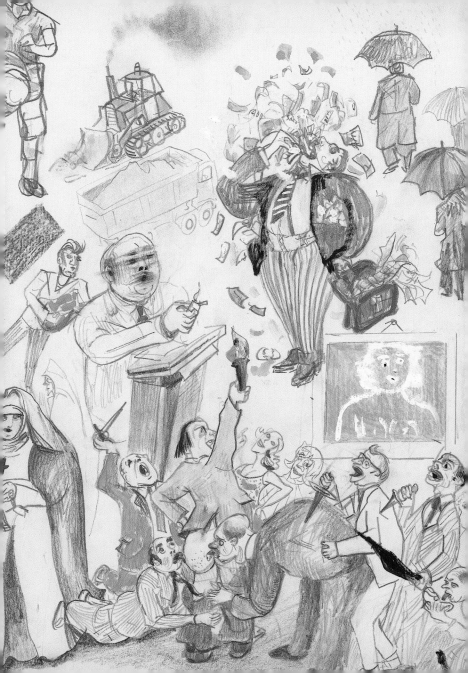

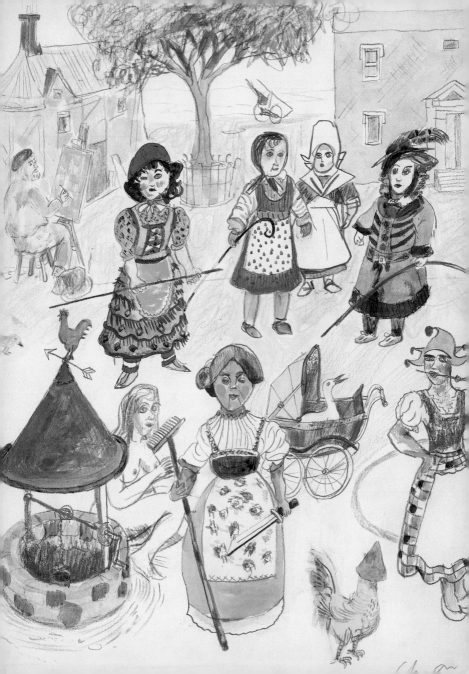

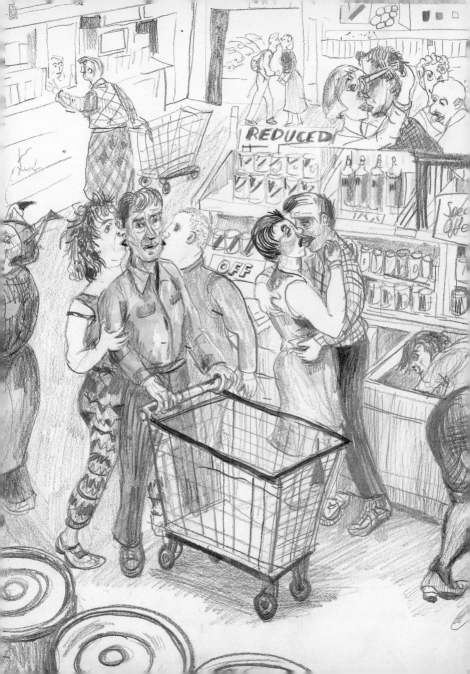

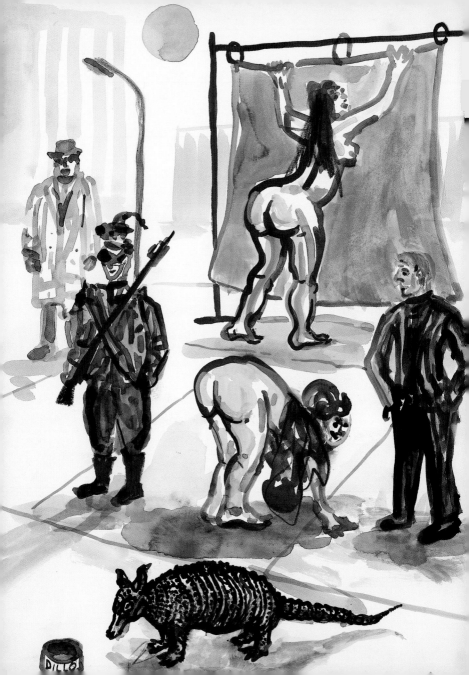

DILLO

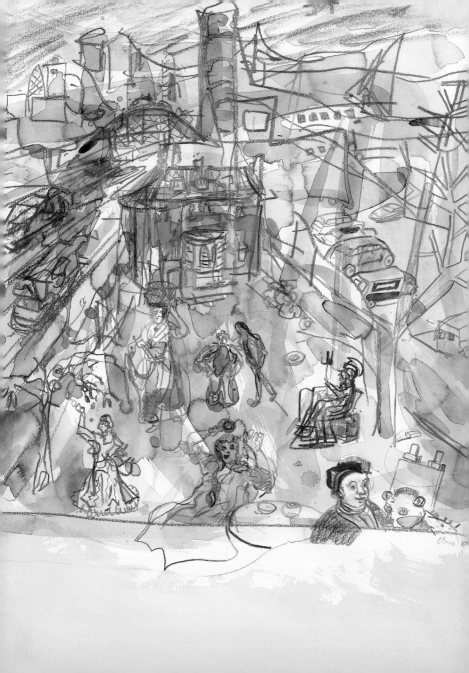

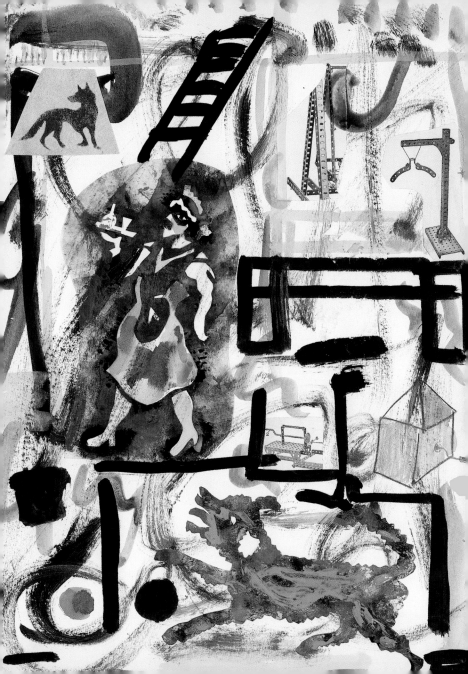

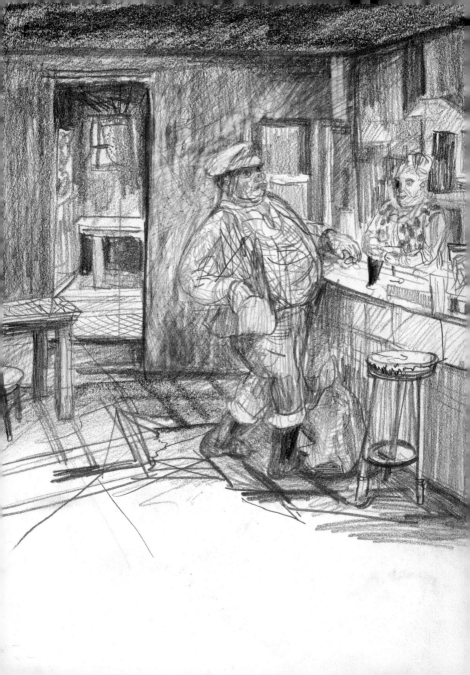

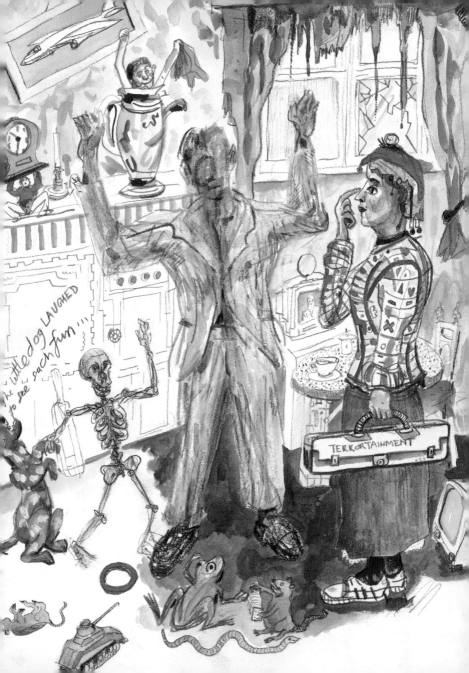

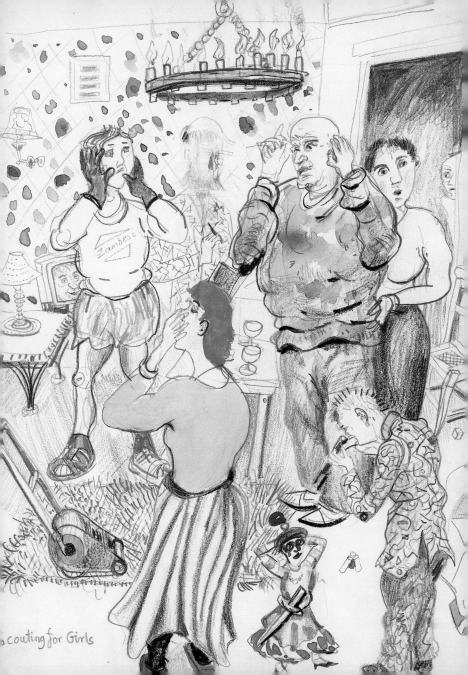

couting for Girls

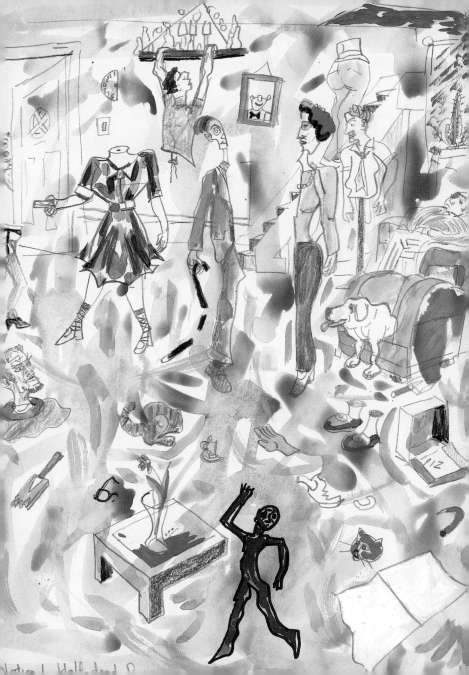

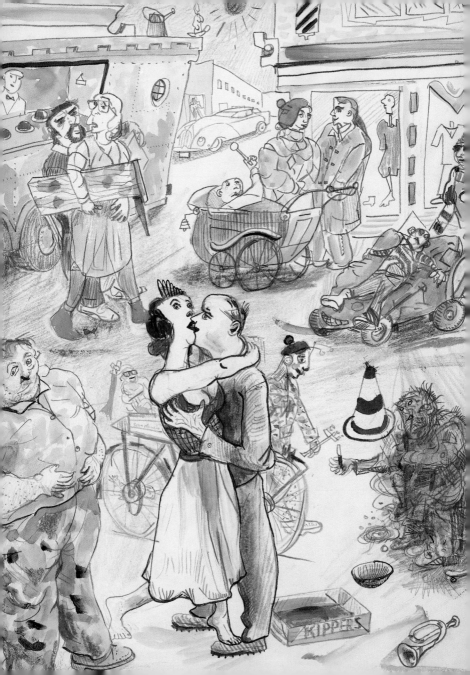

KIPPERS

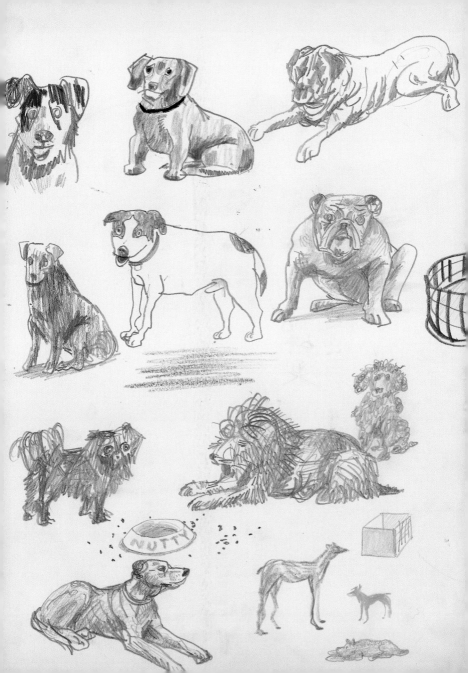

NUTTY

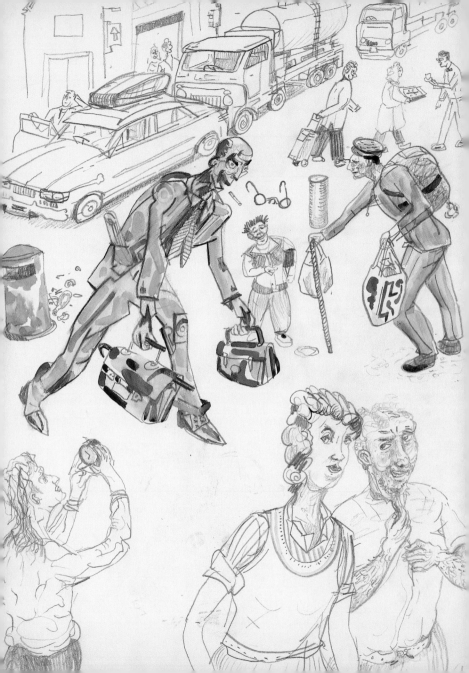

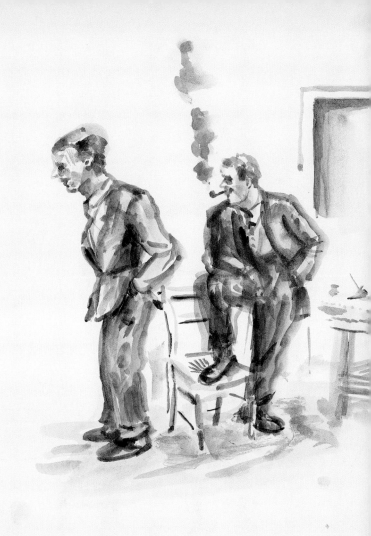

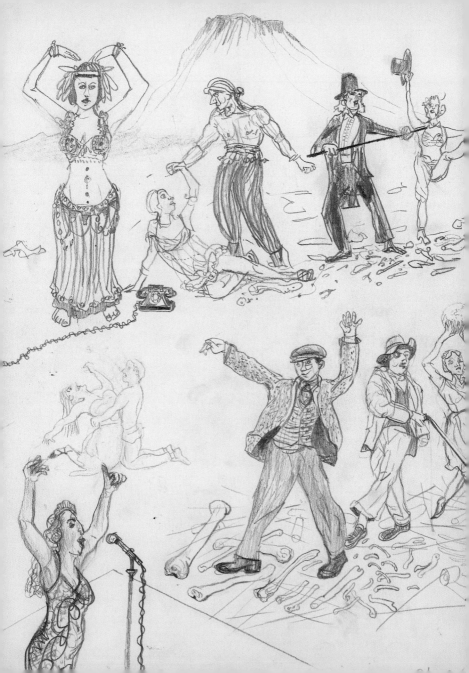

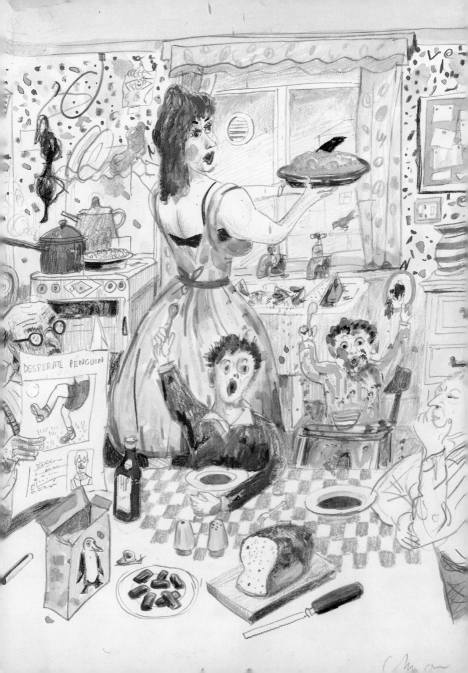

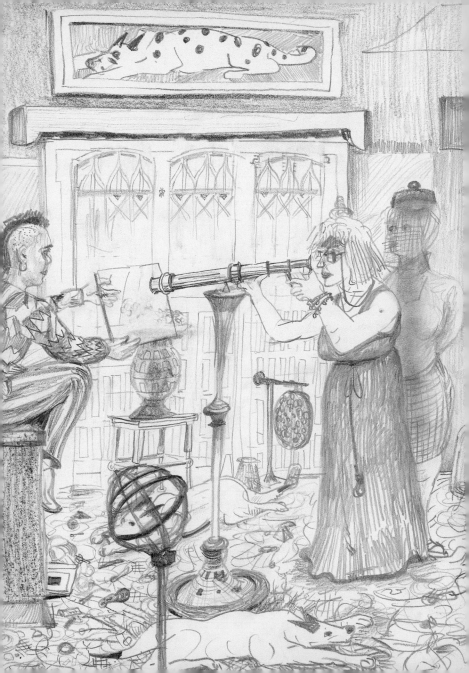

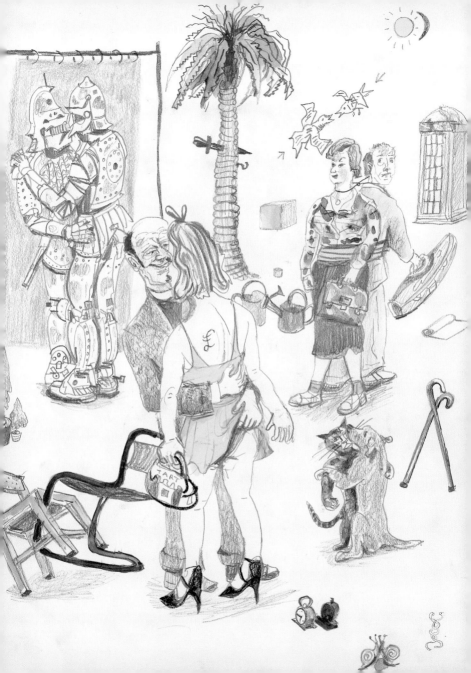

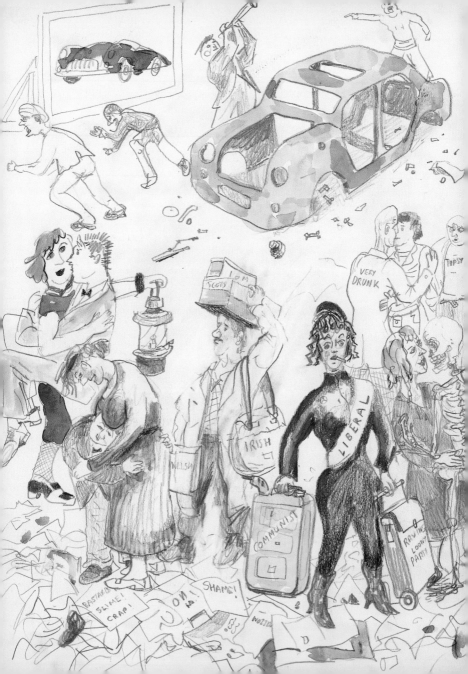

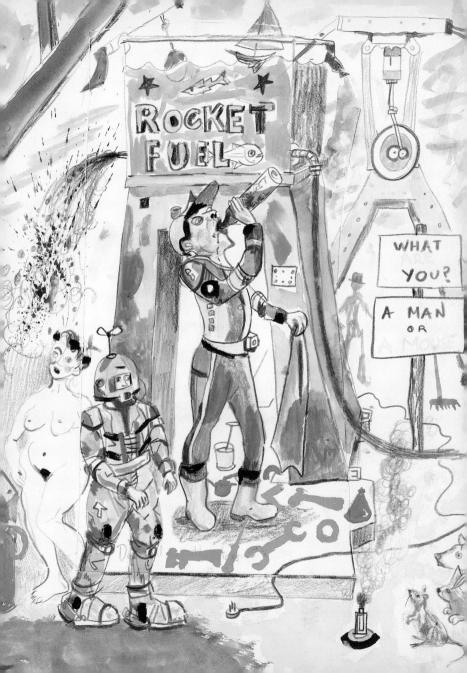

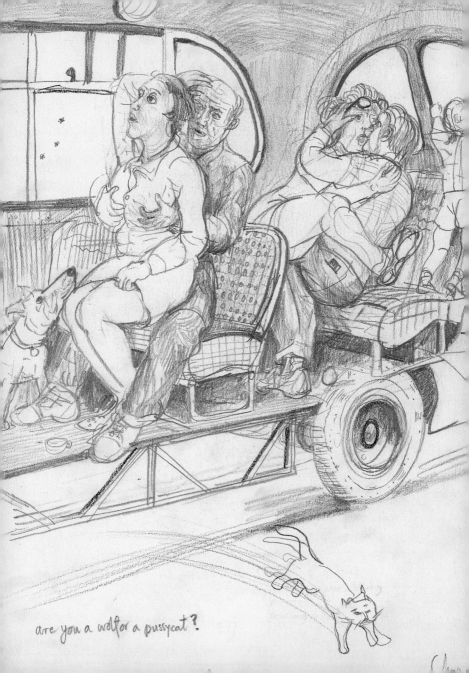

are you a wolf or a pussycat?

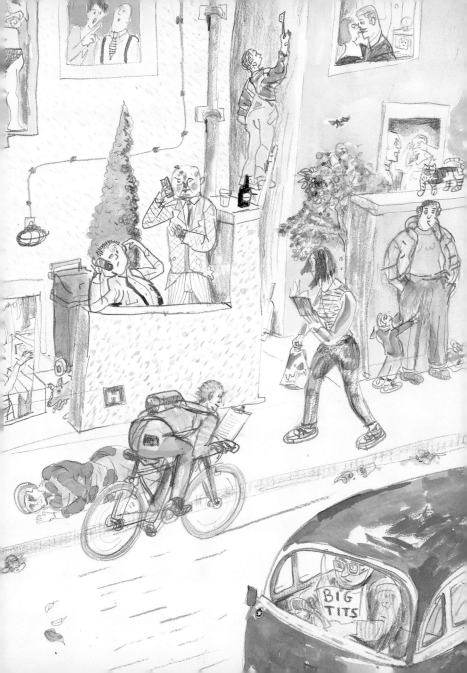

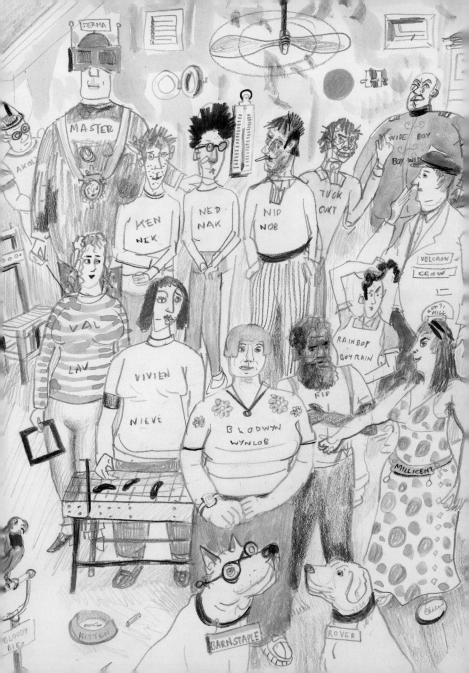

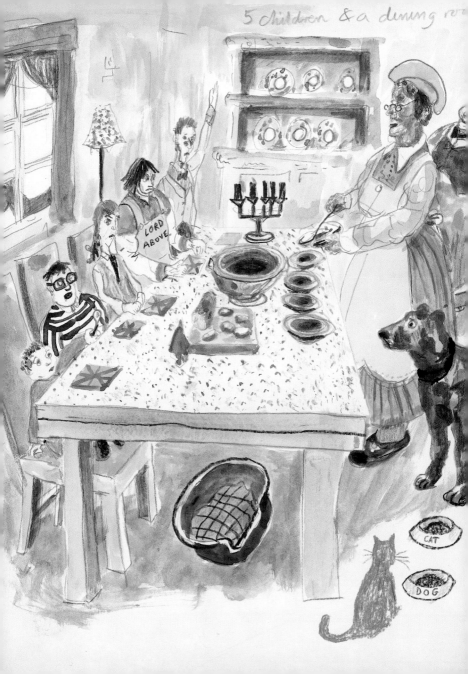

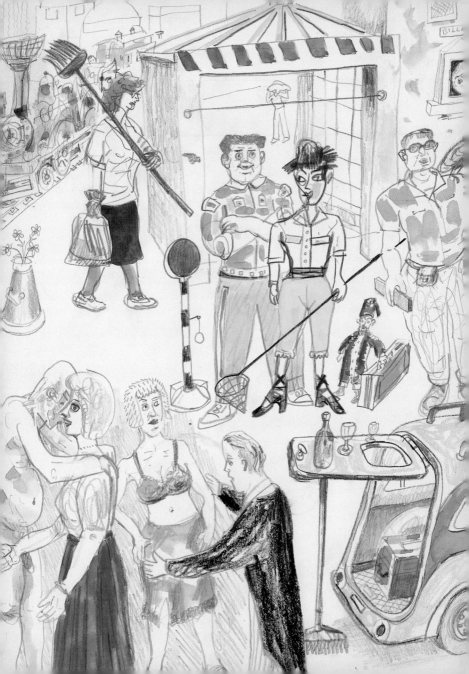

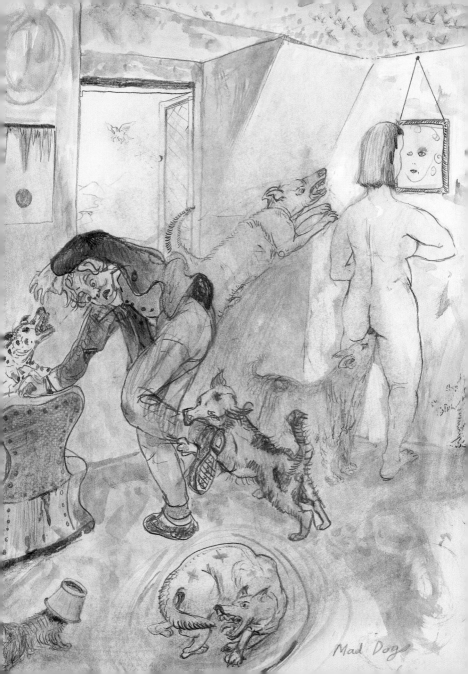

Mad Dogs

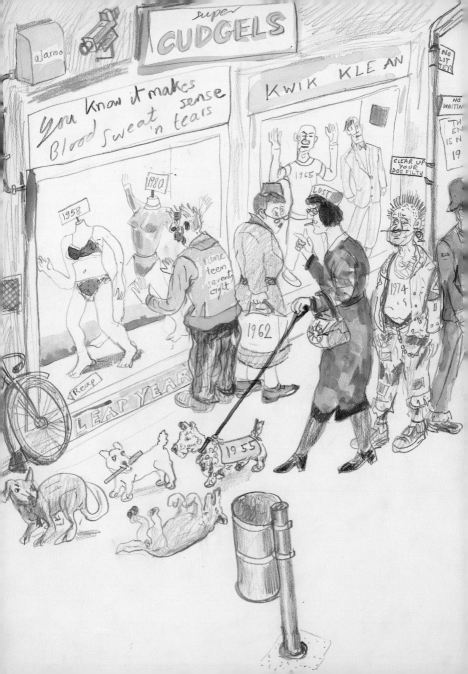

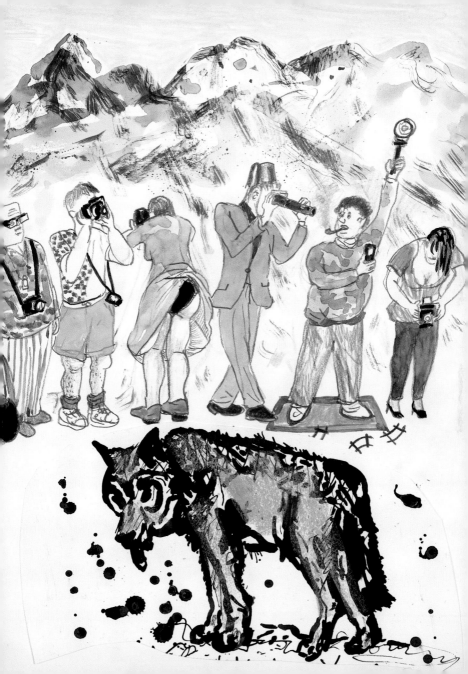

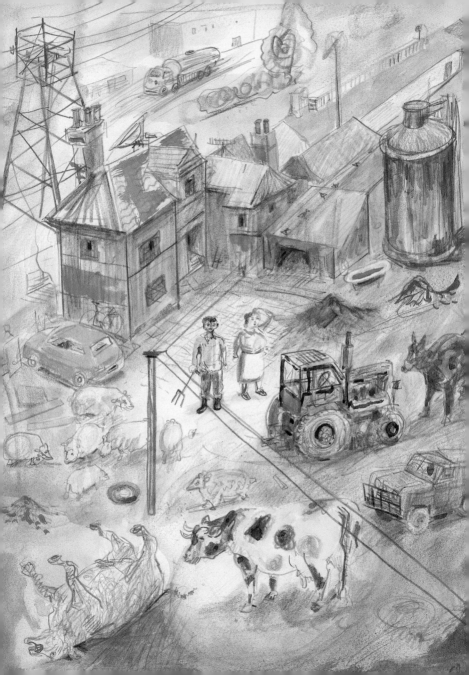

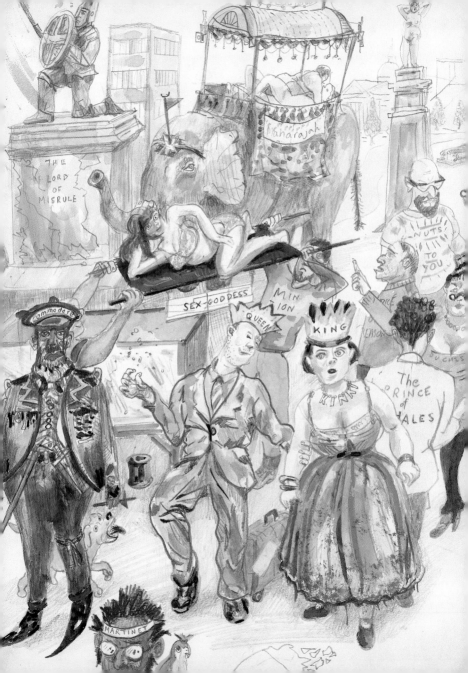

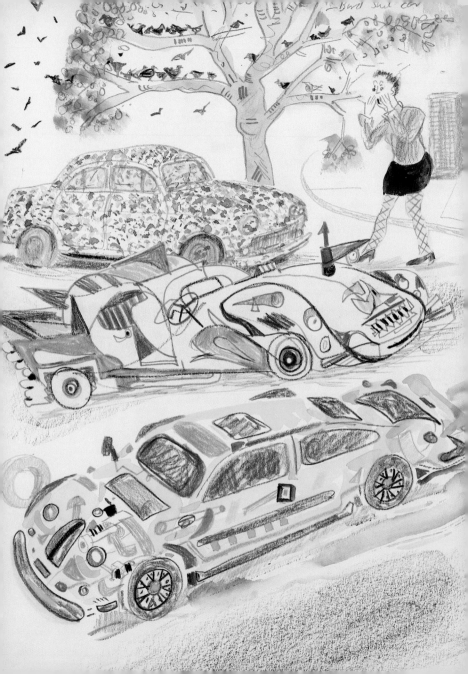

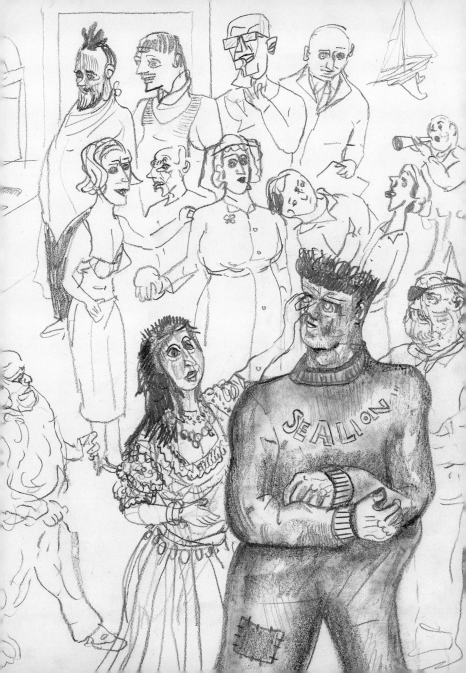

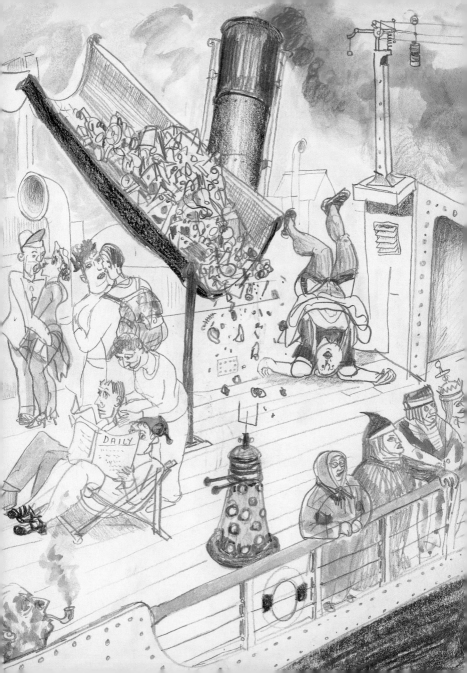

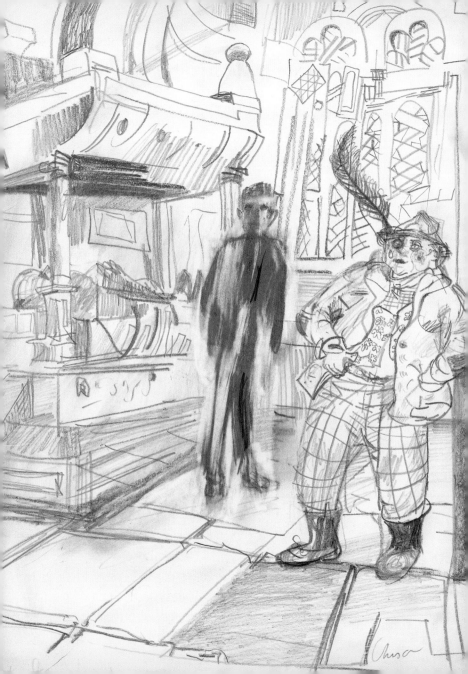

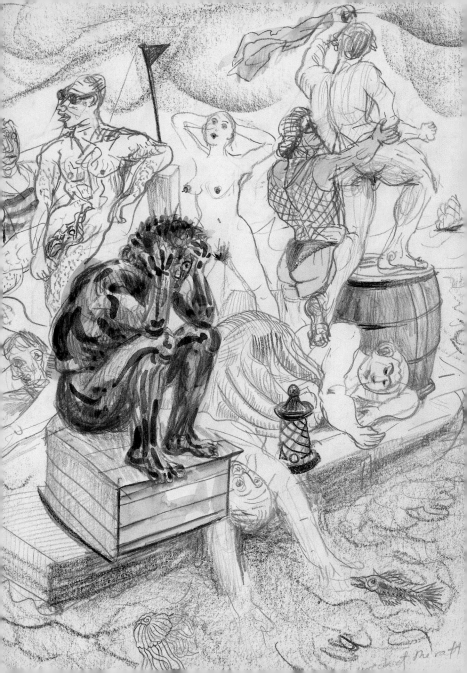

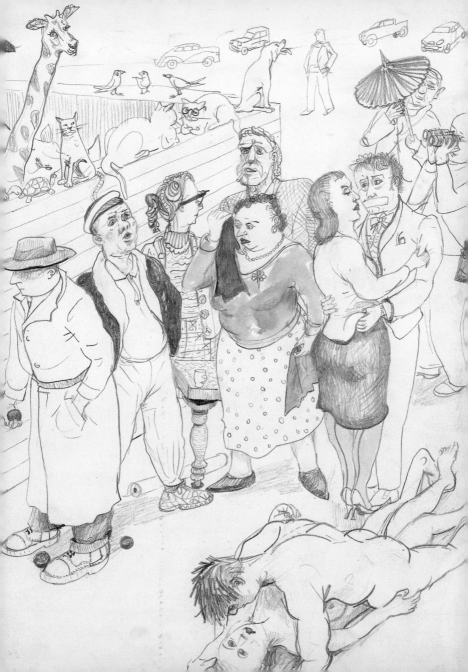

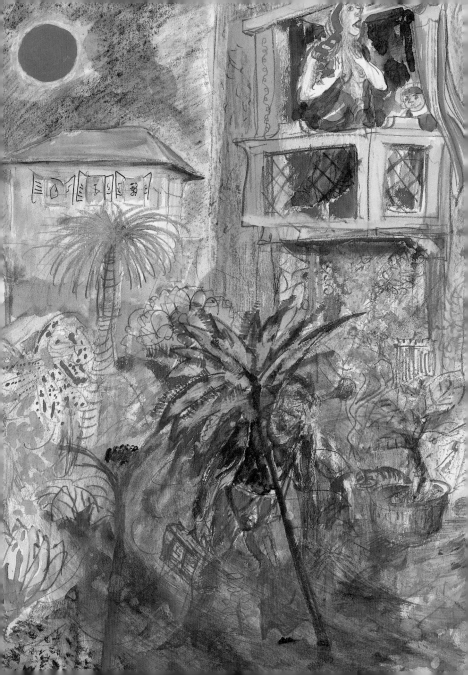

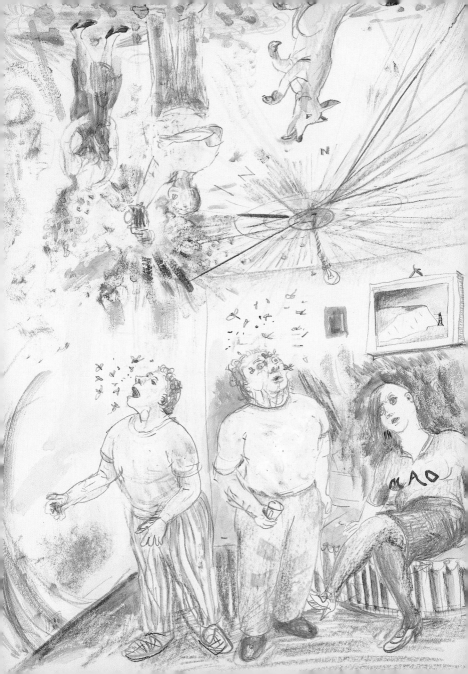

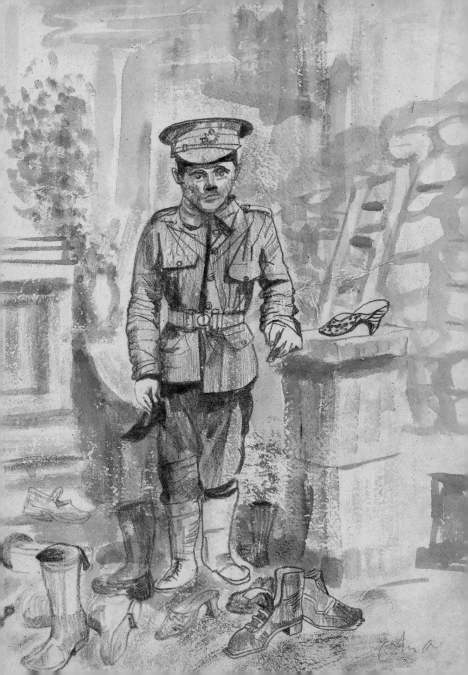

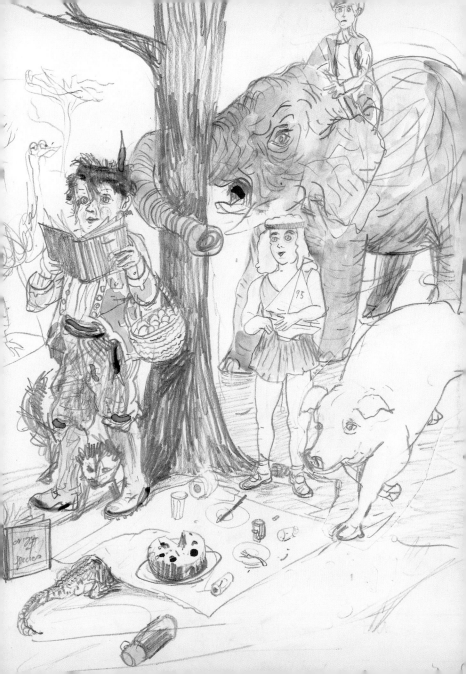

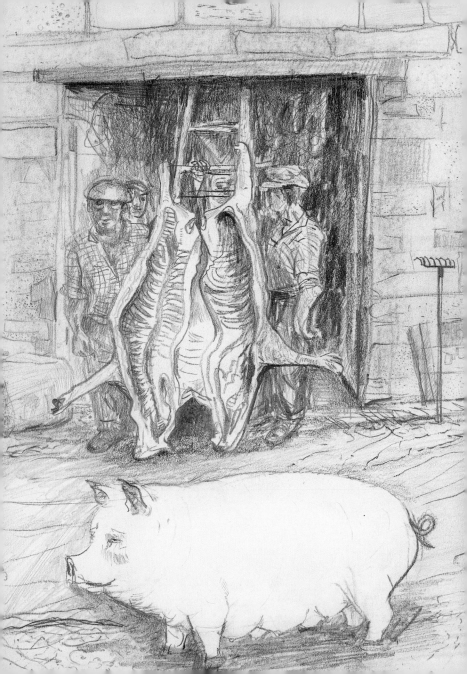

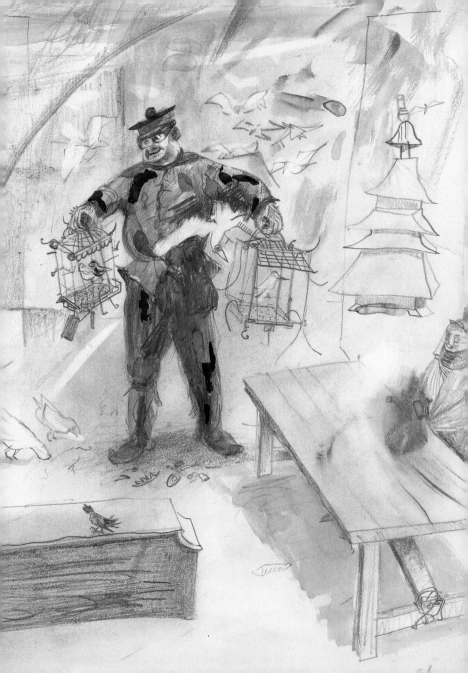

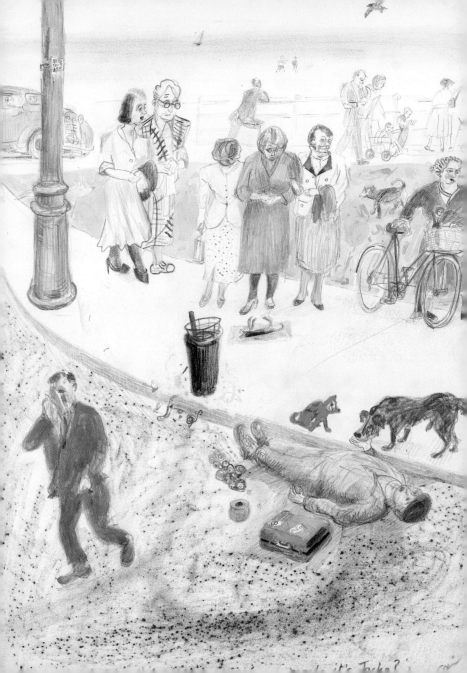

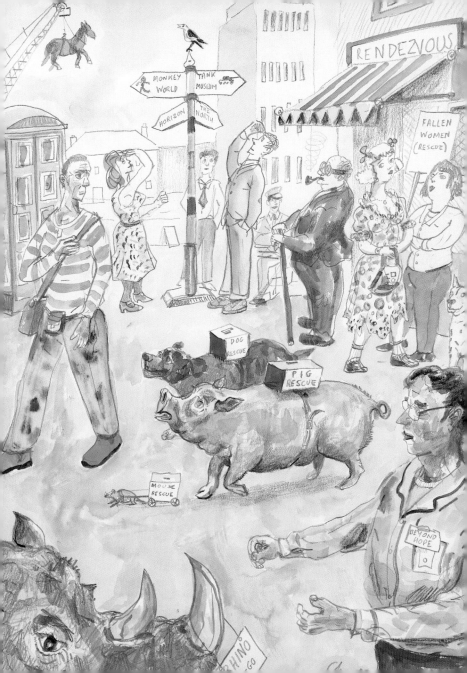

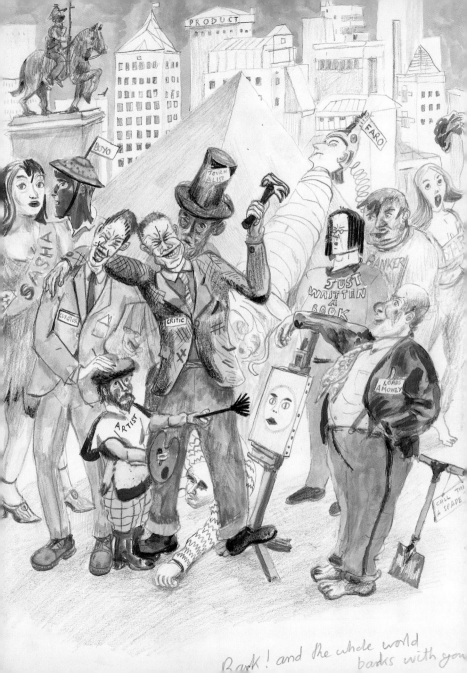

Bark! and the whole world barks with you

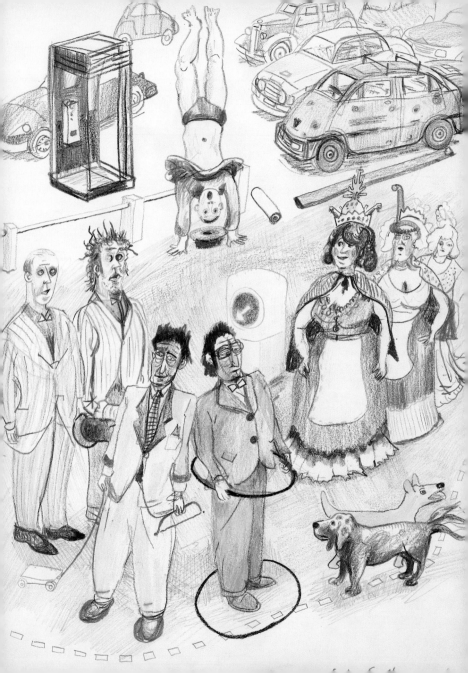

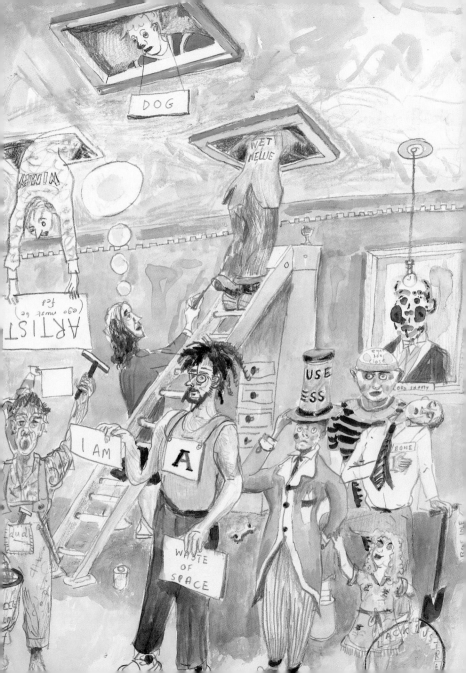

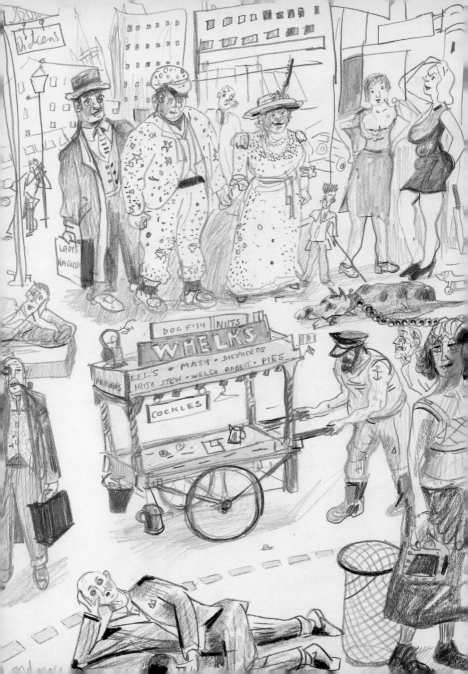

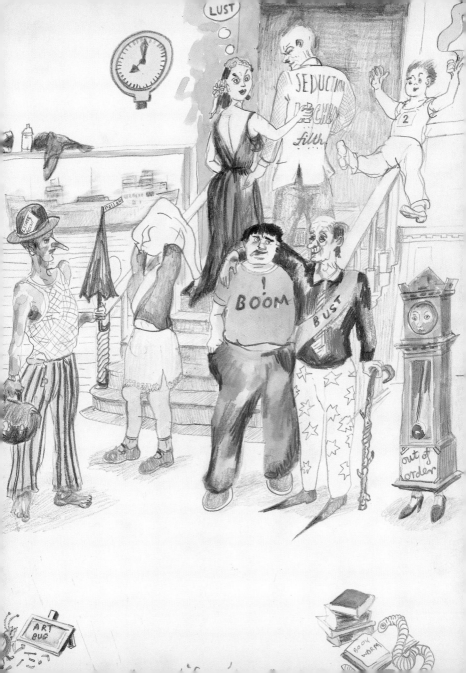

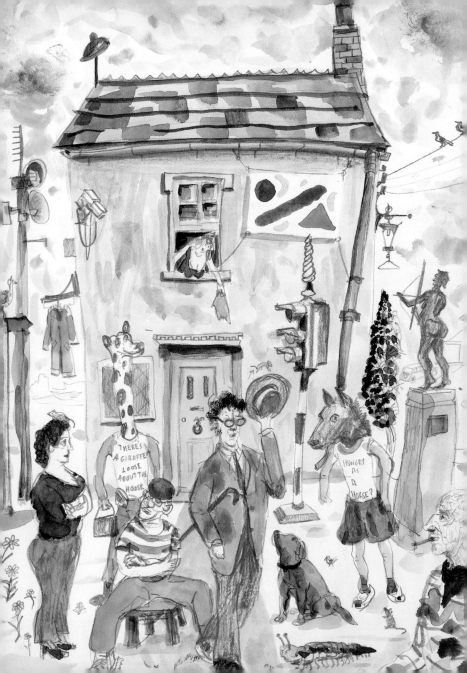

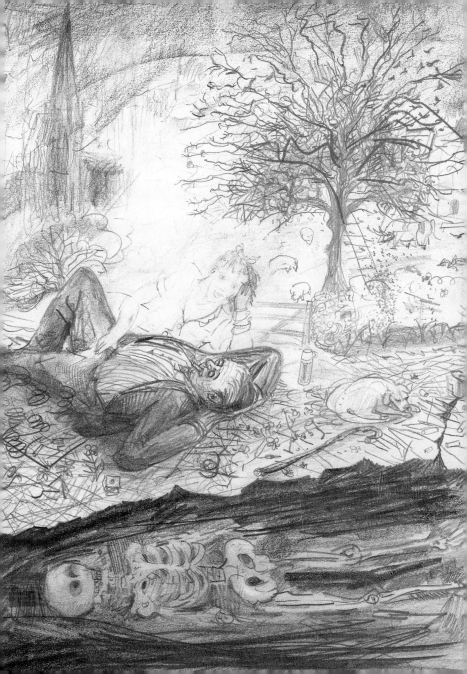

Brass monkey

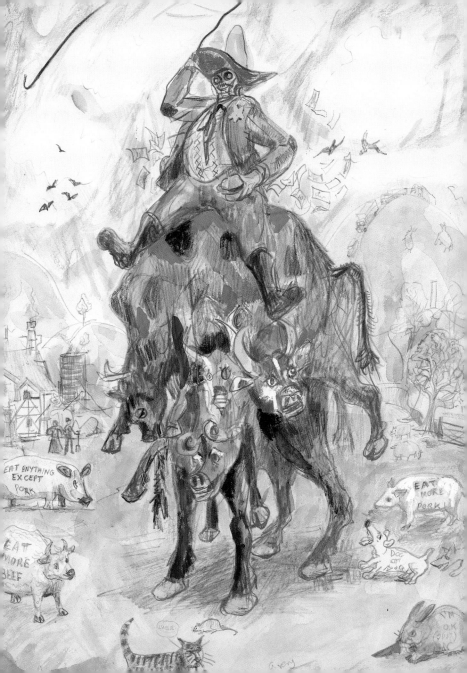

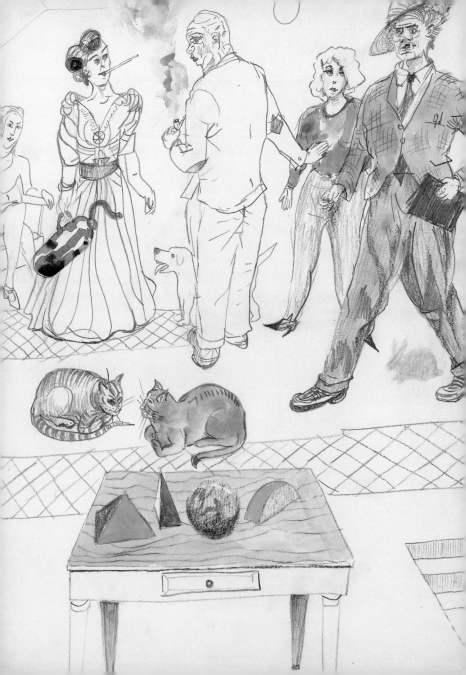

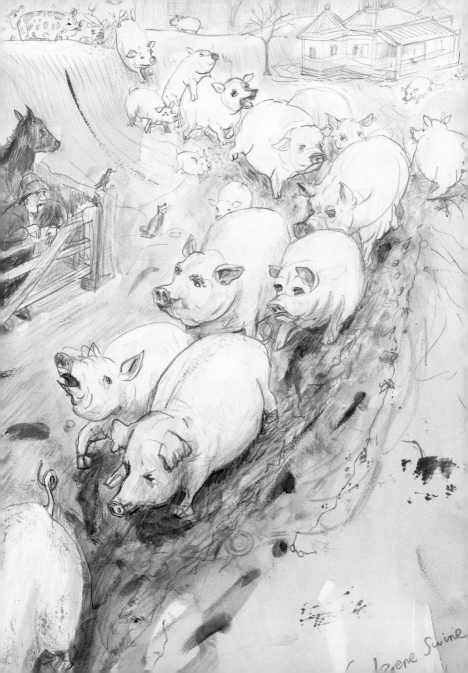

Irene Swine

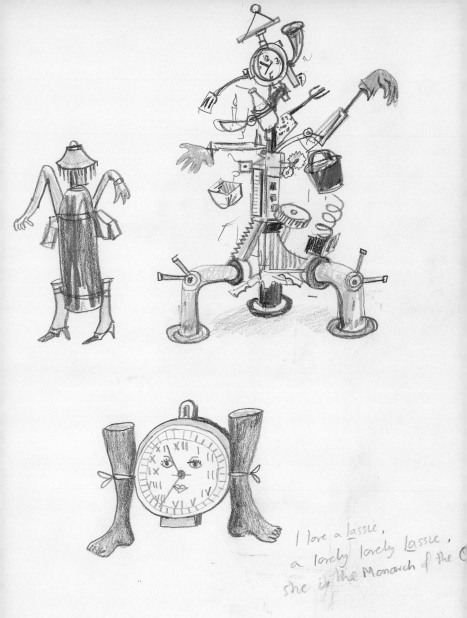

I love a lassie,
a lovely lovely lassie,
she is the Monarch of the G

The sculpture show

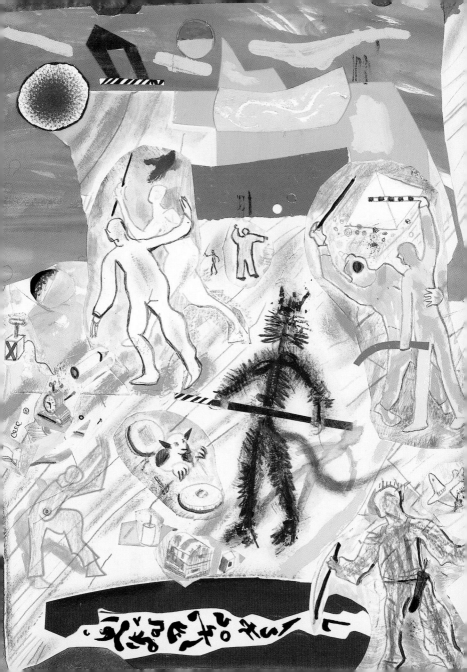

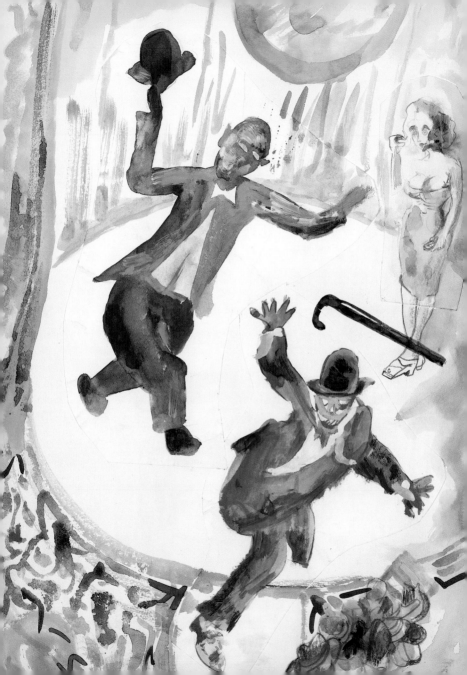

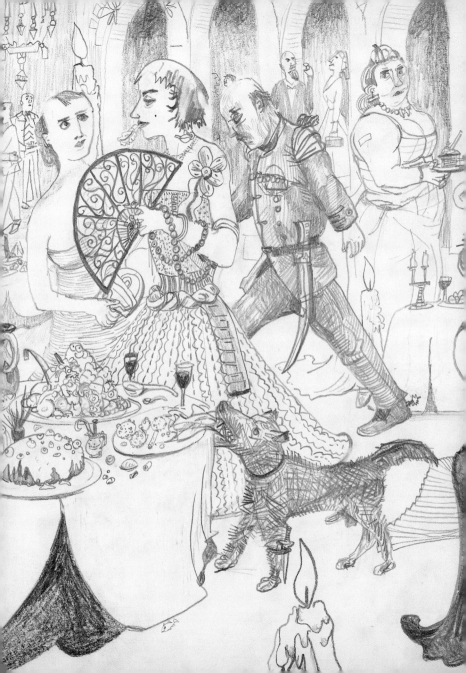

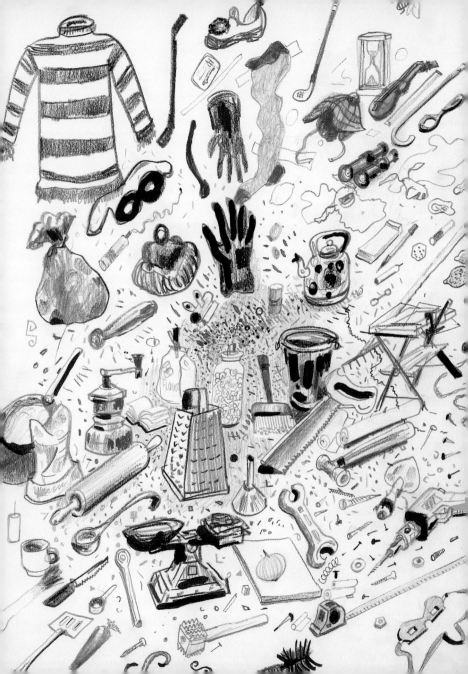

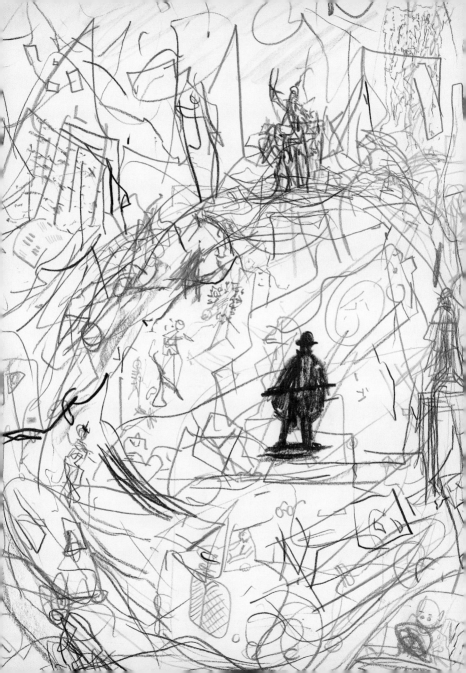

CIRCUS
PICCADILLY

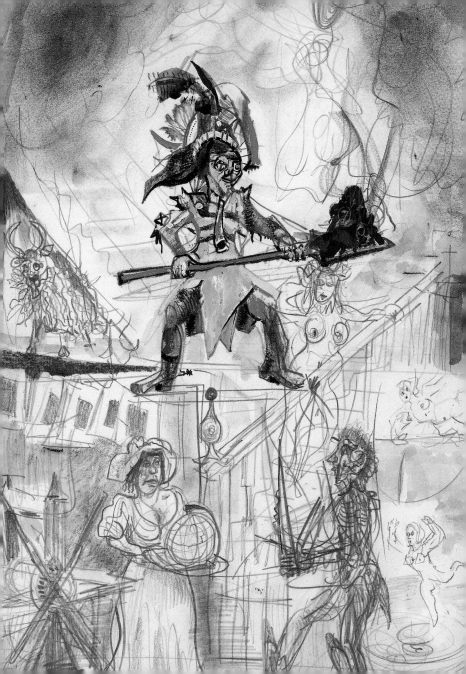

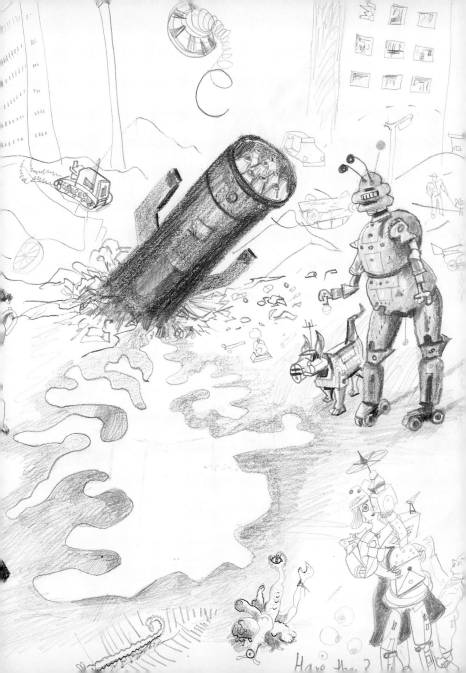

Have the?

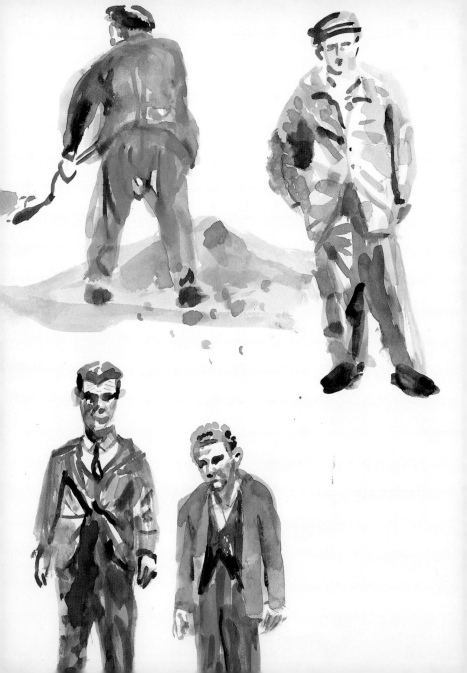

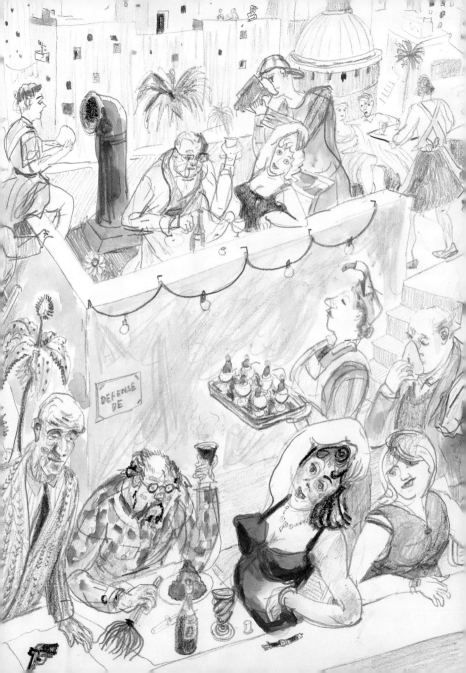

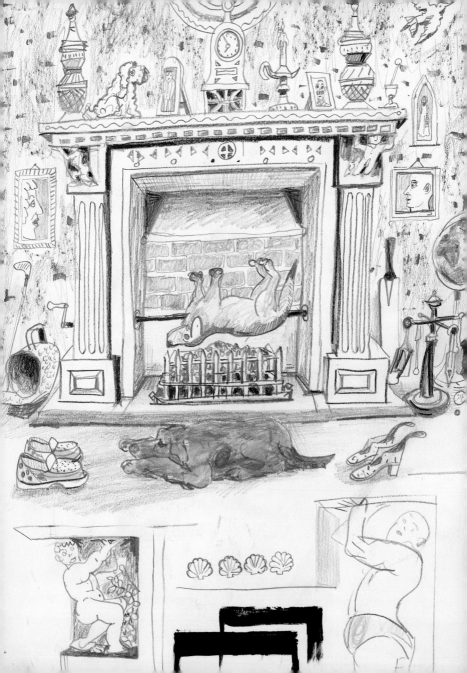

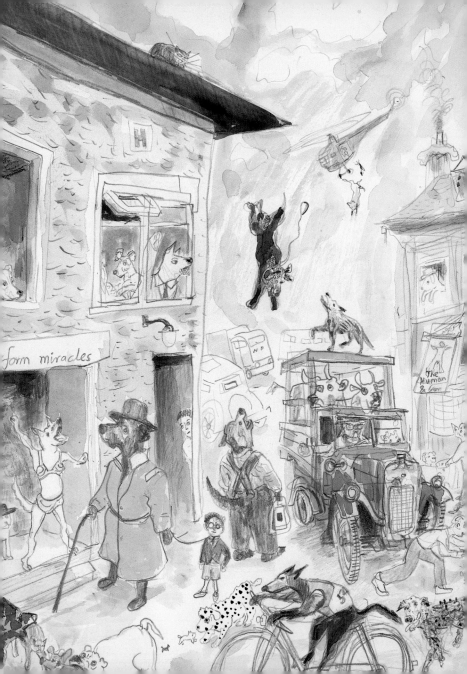

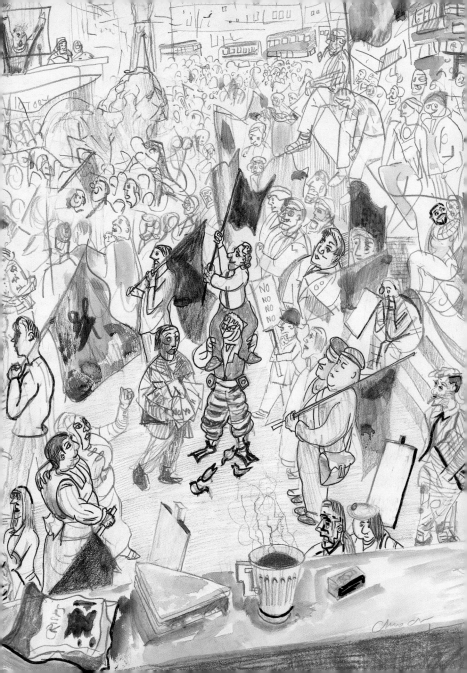

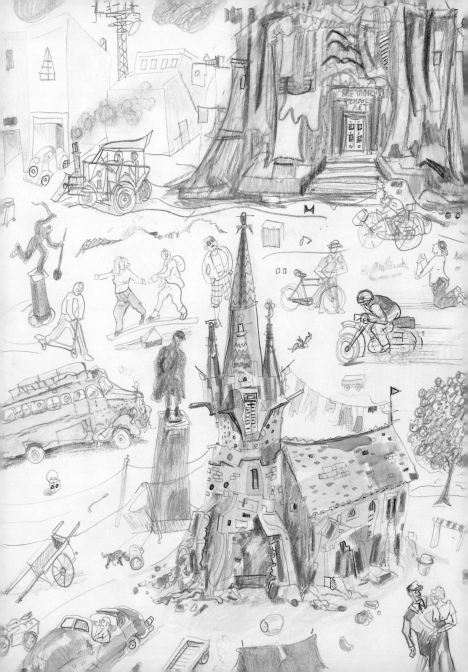

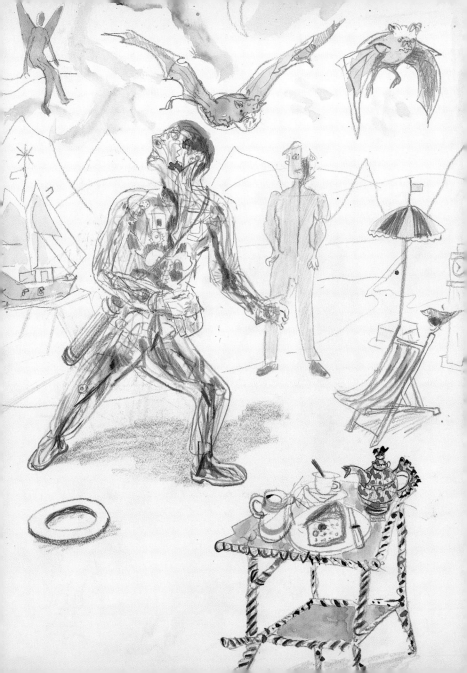

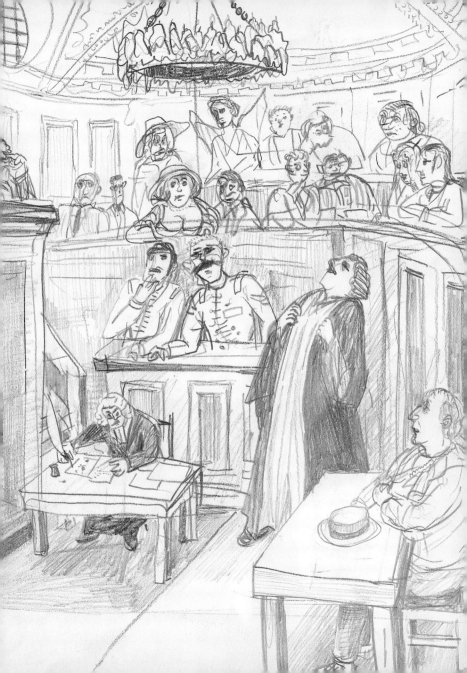

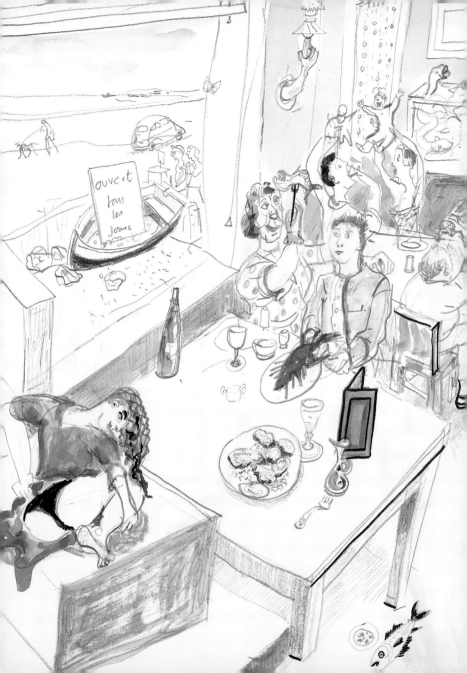

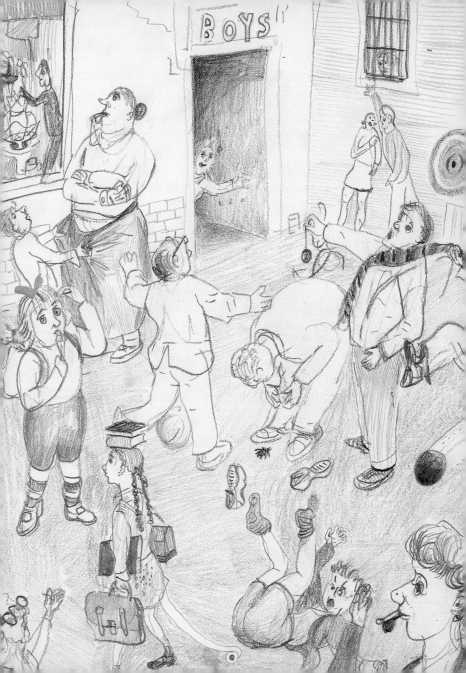

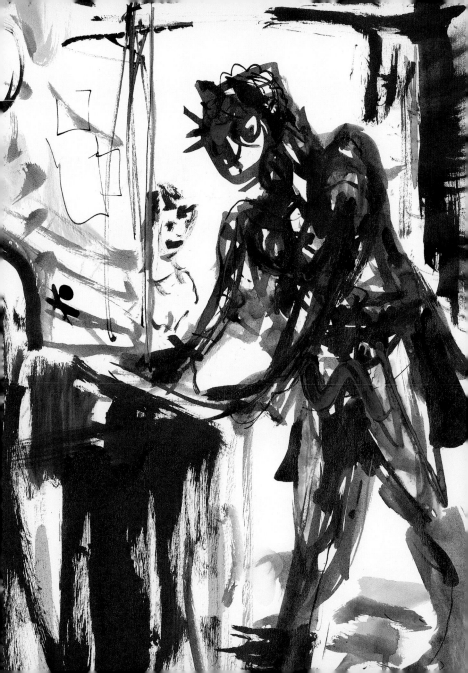

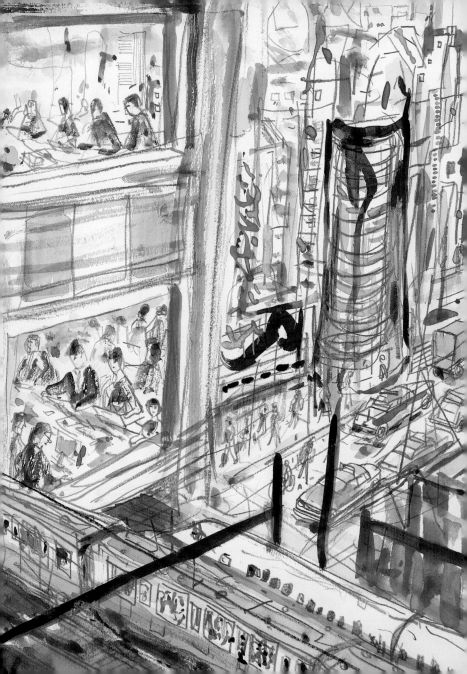

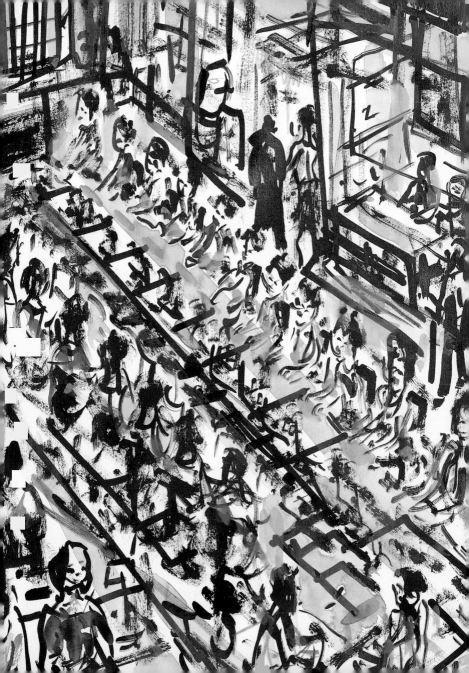